Quarto is the authority on a wide range of topics.
Quarto educates, entertains and enriches the lives of our readers—
enthusiasts and lovers of hands-on living.
www.quartoknows.com

Copyright © 2016 by Rich Davis

First published in the United States of America in 2016 by
Race Point Publishing, a member of
Quarto Publishing Group USA Inc.
142 West 36th Street, 4th Floor
New York, New York 10018
quartoknows.com

10 9 8 7 6 5 4 3 2 1

ISBN 978-1-63106-254-4

Editorial Director: Jeannine Dillon
Managing Editor: Erin Canning
Project Editor: Jason Chappell
Art Director: Merideth Harte
Cover and Interior Design: Melissa Gerber

Printed in China

# CONTENTS

# INTRODUCTION

Children find cartoons and whimsical drawings magnetic and are easily drawn to them. *The 1-Minute Artist* teaches children of all ages how to draw silly things, quickly and easily, in 6 or 12 steps. The beauty of the drawings in this book is that they are simple, easy to learn, and take very little time—only 1 minute!—to accomplish a lot. The confidence that comes from artistic experimentation is powerful. Combine that with the confidence that comes from repetition and you have a winning combination. Artistic experimentation also encourages the development of ideas—those ideas will not be limited just to drawing, but to other areas of one's imagination and learning experience. The more your children draw the simple creations in this book, the more their imaginations will guide them to draw more!

## How to Use This Book

Here are some helpful tips to not only get your children drawing, but to also make it a fun and rewarding experience for everyone involved. The most important thing to keep in mind is that there are no strict rules and deviating from the lines in this book is encouraged. For simplicity, black lines are what is done in that step, gray lines are from previous steps, and blue lines are erasures.

## TIMING

It takes approximately 1 minute to draw nearly everything in this book. Timing things is an amazing motivator—it promotes focus and gives a clear start and end time. When I draw with kids, I always give them a time to shoot for. I find that this results in children giving their best and most prolific work. Encouragement works wonders, so don't be afraid to say things like "You're doing great! You've only used 20 seconds of your time! Keep going, don't panic, you'll make it!" In the last 10 seconds, feel free to take it up a notch and push them a bit, saying "Hurry! Hurry! You can do it!"

# PRACTICING

The best advice I have to accompany this book is to always have scrap paper on hand for practicing. The cartoonish creations you learn to make in *1-Minute Artist* invite you to combine them to create scenes and stories. Scrap paper will help you practice the sketch before adding it to a scene. If a complicated scene involving multiple elements is in progress, scrap paper helps keep people of any age group calm; there's little chance of ruining the scene with a messed up drawing. Of course, plenty of space has been provided in this book to practice your sketches.

# CREATING

The 10 chapters of this book have distinct themes, such as animals, architecture, transportation, and people. You may notice that there is often crossover among the chapters: a doodlebug drives a convertible, a bird wears a hat, and so on. This encourages children to imagine the possibilities and combine creations across the chapters. I also offer suggestions at the beginning of each chapter to help get you started. You may even want to encourage your children to write stories for every scene they create!

# MOTIVATING

Finally, one of the strongest motivators you can give your kids is to participate in drawing with them. Try it out! There is something magical when children see adults not only encouraging them, but actively participating in the same activity. They absolutely love it. Forget whether you have no artistic ability at all! Your kids will be complimentary of even a poor drawing that you create with them. Enjoy!

# CHAPTER 1

## ANIMALS

In this chapter you'll learn how to draw your favorite animals, including dogs, cats, cows, frogs, rabbits, and more . . . all in just 6 easy steps! To get even more creative, try some of the suggestions for creating an animal scene on the next page. And don't forget your 12-Step Challenge—see if you can draw the ice-skating penguin on page 22!

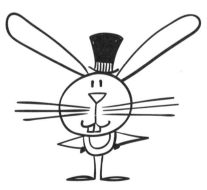

# TRY These TOO!

## Make a scene using the animals in this chapter!

### HERE'S SOME INSPIRATION

ONCE YOU'VE MASTERED ALL THE ANIMALS IN THIS CHAPTER, TRY MAKING A SCENE WITH THEM! THIS IS THE FUN PART. I PUT SOME SUGGESTIONS BELOW TO JUMP-START YOUR CREATIVITY. AND DON'T HESITATE TO USE YOUR NEW SKETCH SKILLS TO MODIFY ANY OF THE ANIMALS HERE. EXPERIMENT WITH THEM IN DIFFERENT POSES OR HAVE THEM DO "PEOPLE" THINGS LIKE EAT PIZZA OR PLAY SOCCER. THE SKY IS THE LIMIT!

• DRAW A FROG (PAGE 14) SITTING ON A LILY PAD. THEN, DRAW A PENGUIN ICE SKATING (PAGE 22) IN FRONT OF THE FROG. THROW A HAT ON THE FROG TO KEEP HIM WARM!

• WHAT IS THE TURTLE (PAGE 20) RUNNING FROM? USE SOMETHING FROM THE TRANSPORTATION CHAPTER (PAGE 108) TO SHOW WHAT HE IS RUNNING FROM.

• GIVE YOUR ANIMALS SOME CHARACTER AND EMOTION BY ADDING THOUGHT BUBBLES NEAR THEM. WHAT ARE THEY THINKING ABOUT? WRITE OR DRAW IT IN!

• DRAW THE HAPPY JUMPING CAT (PAGE 13). WHY IS HE SO HAPPY? IS IT HIS BIRTHDAY? OR IS HE GLAD TO SEE SOMEONE? DRAW IT IN!

• MAKE YOUR ANIMAL SCENE EVEN MORE ELABORATE BY DRAWING ANY OF THE LITTLE ANIMAL CHARACTERS I HAVE ADDED TO THIS PAGE AND THE OPPOSITE ONE!

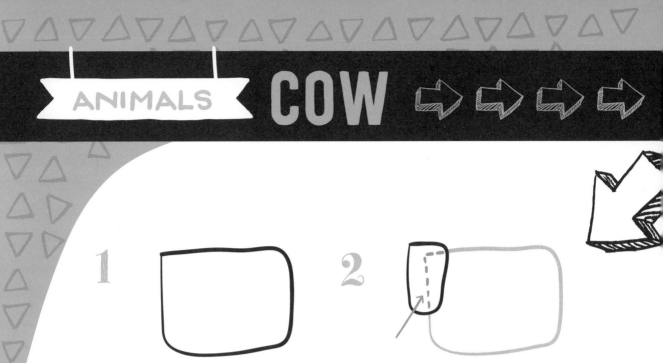

1

2

3

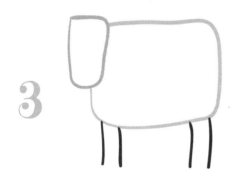

4

5

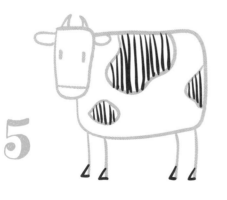

6

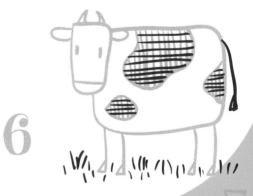

# ANIMALS  MR. PUDDLETON

YOUR TURN!

# CAT

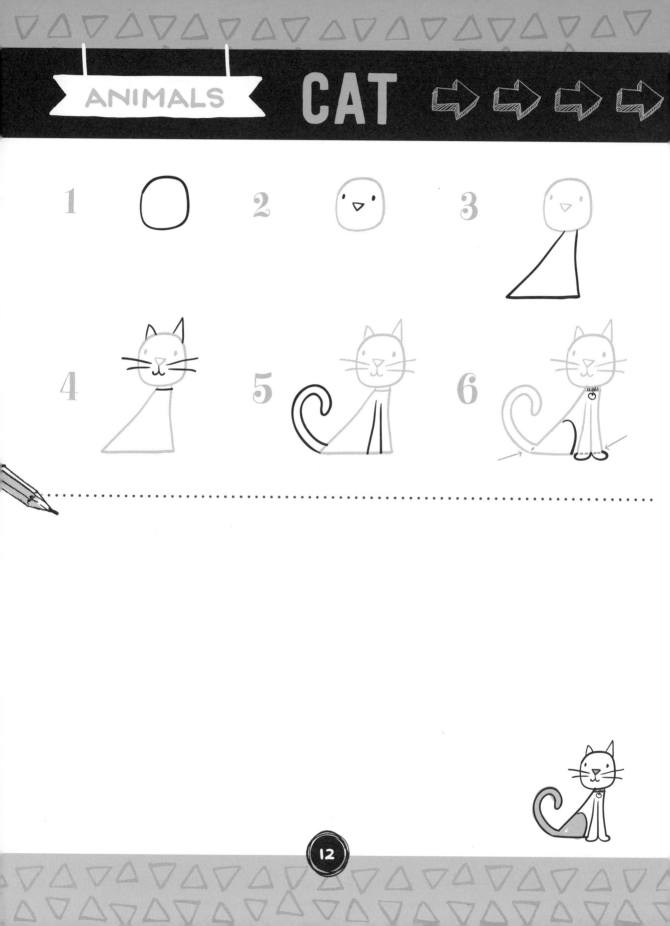

1

2

3

4

5

6

# JUMPING CAT

1

2

3

4

5

6

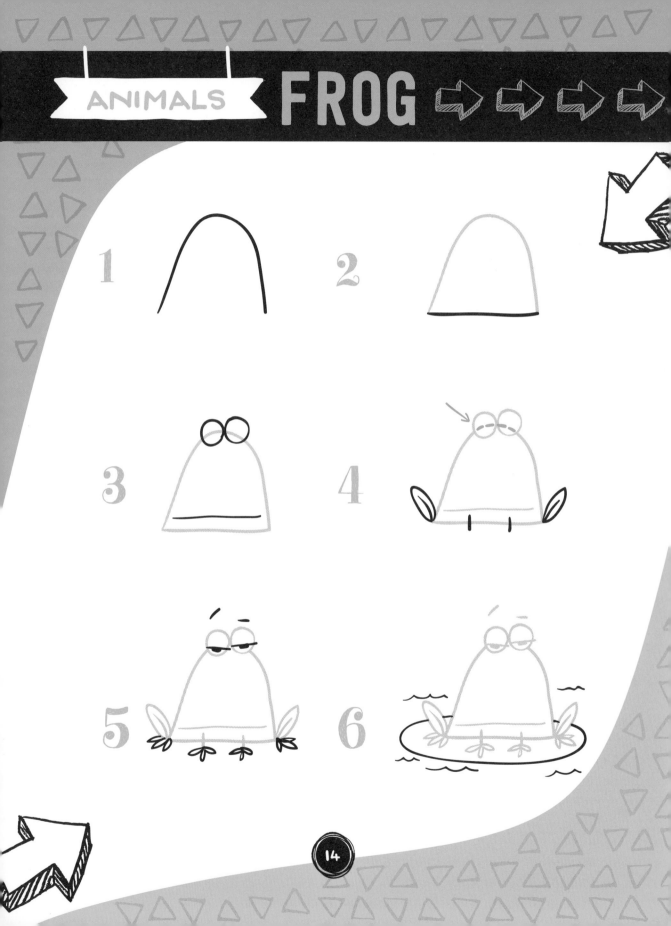

1

2

3

4

5

6

14

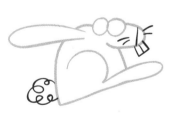

BOING!

YOUR TURN!

# ANIMALS
## ZEBRA

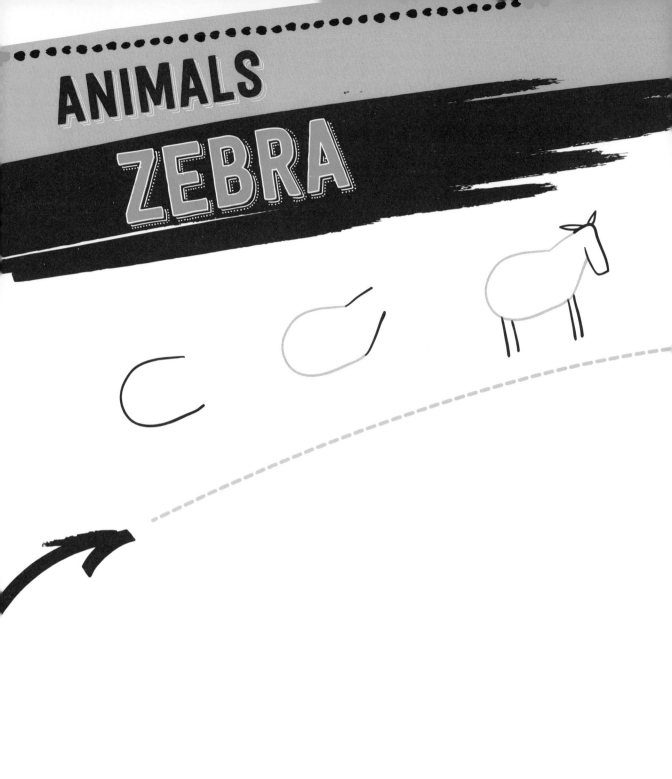

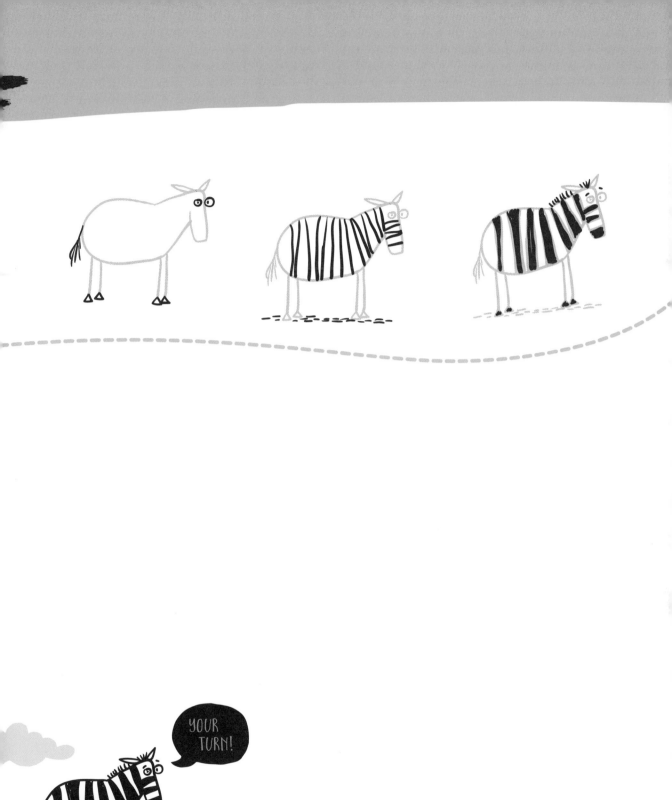

YOUR TURN!

(Practice your new skills in the area above.)

19

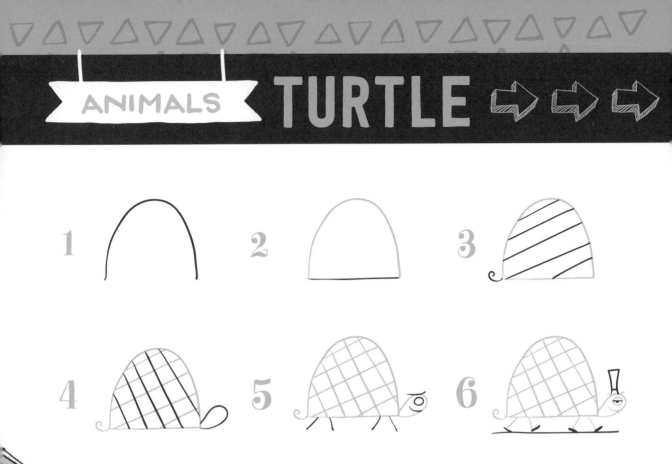

1  2  3

4  5  6

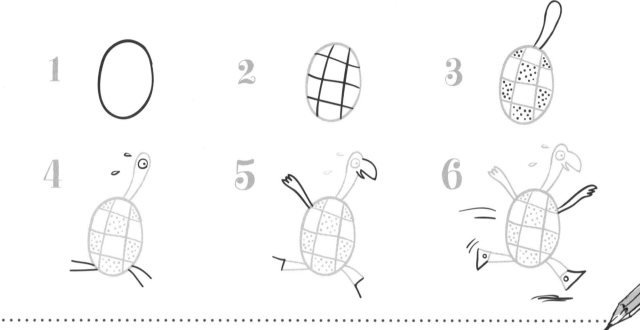

1
2
3
4
5
6

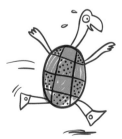

YOUR TURN!

# CHAPTER 2

## BIRDS

In this chapter you'll learn how to draw different birds, including ducks, chickens, roosters, hens, and more . . . all in just 6 easy steps! To get even more creative, try some of the suggestions for creating a bird scene on the next page. And don't forget your 12-Step Challenge—see if you can draw the mom and chick on page 38!

# TRY These TOO!

*Birds can add life to any scene, whether they're flying above buildings or nesting in trees.*

## HERE'S SOME INSPIRATION

ONCE YOU'VE MASTERED ALL THE BIRDS IN THIS CHAPTER, TRY MAKING A SCENE WITH THEM! THIS IS THE FUN PART. I PUT SOME SUGGESTIONS BELOW TO JUMP-START YOUR CREATIVITY. AND DON'T HESITATE TO USE YOUR NEW SKETCH SKILLS TO MODIFY ANY OF THE BIRDS HERE. EXPERIMENT WITH THEM IN DIFFERENT POSES OR HAVE THEM DO "PEOPLE" THINGS LIKE WEAR HATS OR READ A BOOK. THE SKY IS THE LIMIT!

- ALWAYS MAKE YOUR FIRST LINE A DECENT SIZE–NOT TOO BIG, BUT NOT TOO SMALL. THIS WILL GIVE YOU MORE ROOM TO DRAW THE REST OF THE BIRD AND CREATE A SCENE AROUND IT.

- QUICKLY LOOK AT A STEP, REMEMBER IT, AND THEN QUICKLY DRAW IT. DO THAT FOR EVERY STEP UNTIL YOUR BIRD IS FINISHED. DON'T CARE ABOUT WHAT YOUR BIRD LOOKS LIKE AT FIRST! PRACTICE WILL MAKE IT GET BETTER!

- TRY TO AVOID ERASING ANYTHING UNTIL AFTER YOU'VE FINISHED DRAWING THE BIRD. ERASING MIGHT TAKE LONGER THAN SIMPLY STARTING FROM SCRATCH!

- ONCE YOU'VE DRAWN A BIRD, TRY DRAWING IT AGAIN TO SEE IF YOU CAN MAKE IT BETTER.

- AFTER YOU HAVE DRAWN 2 OR 3 DIFFERENT BIRDS, DRAW 2 BIRDS FACING EACH OTHER. DRAW SOME SPEECH BUBBLES AND WRITE A CONVERSATION BETWEEN THEM. ARE THEY FRIENDS? OR ENEMIES?

# BIRDS

## DUCK

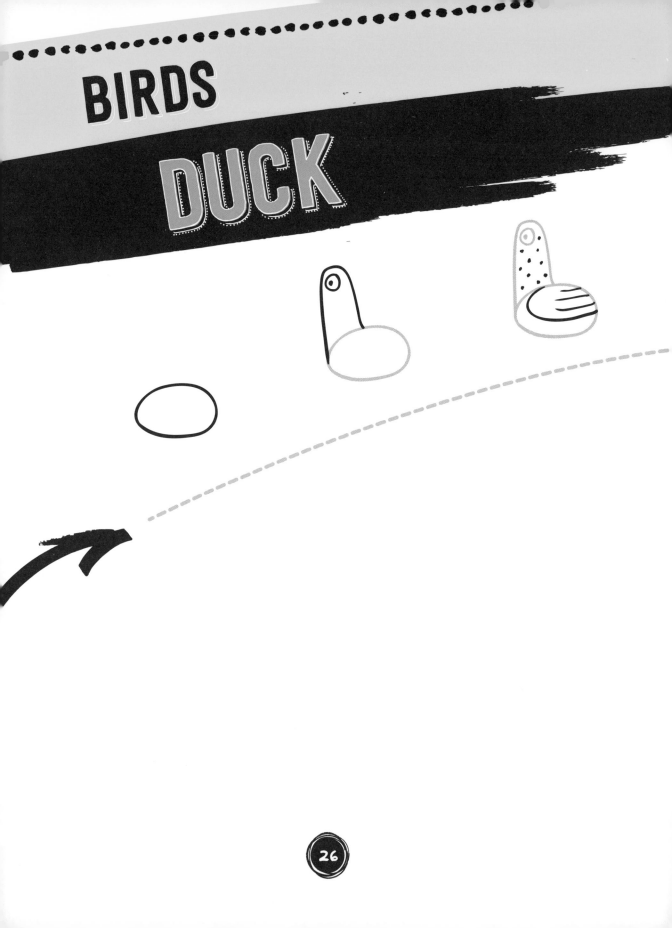

# BIRDS → PIGEON

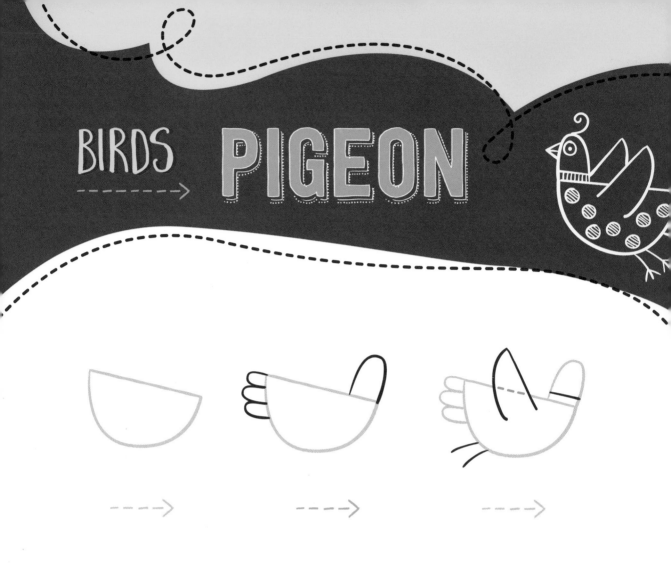

YOUR TURN!

# DANDY

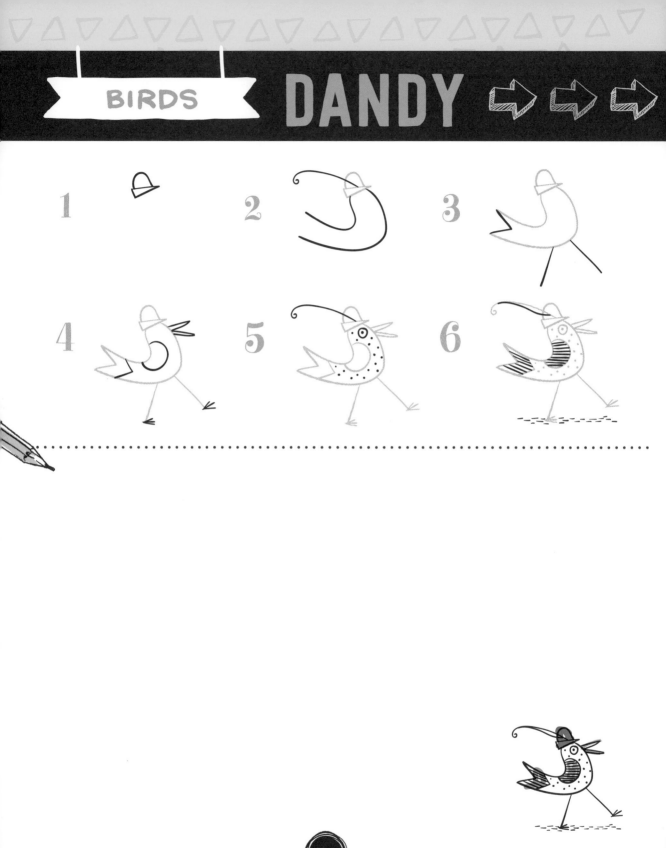

1  2  3

4 5 6

# BIRDS

## CHICKEN

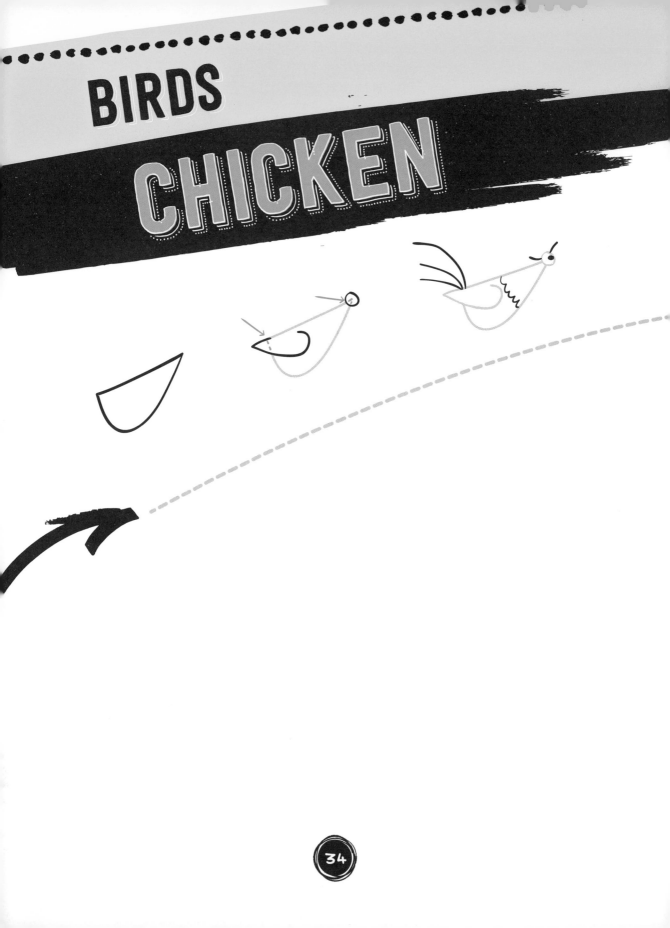

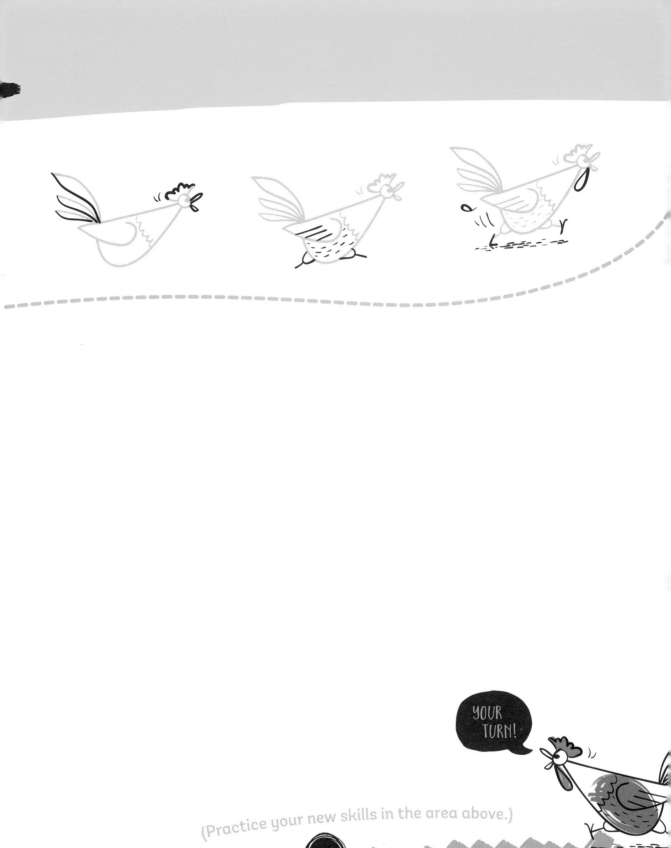

YOUR TURN!

(Practice your new skills in the area above.)

# GOOSE

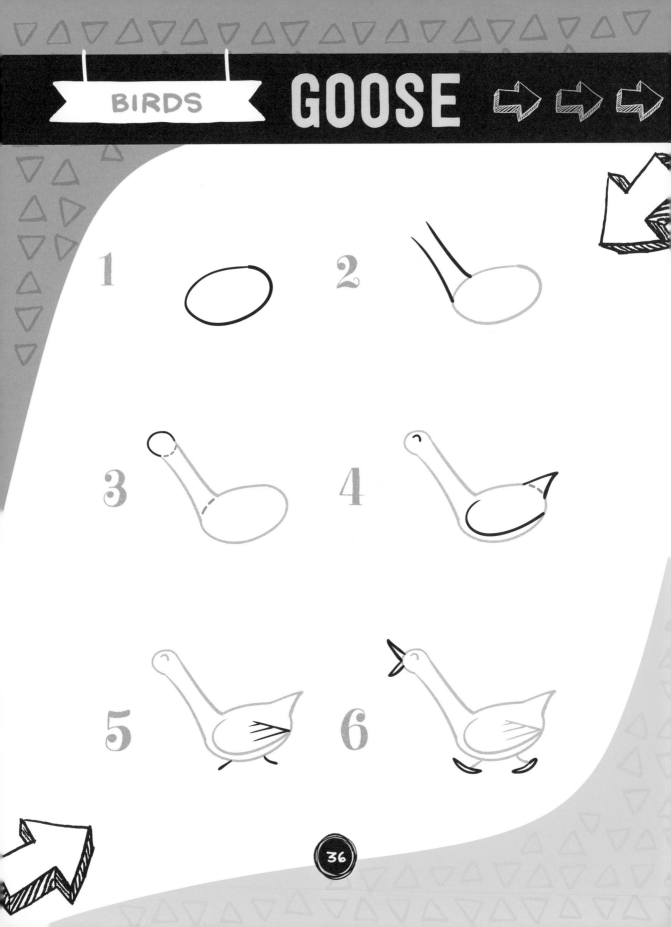

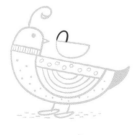
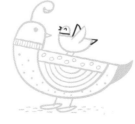
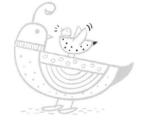

38

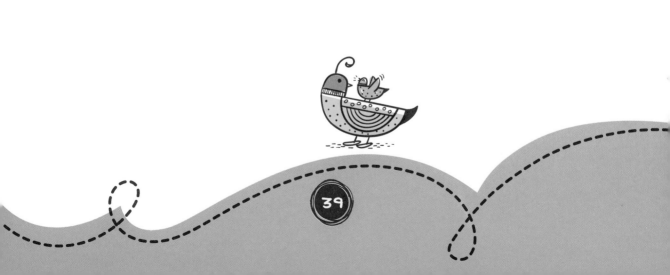

39

# CHAPTER 3

## ARCHITECTURE

In this chapter you'll learn how to draw different buildings, including houses, castles, barns, grass huts, and even some famous buildings, such as Notre Dame and the White House . . . all in just 6 easy steps! To get even more creative, try some of the suggestions for creating a city scene on the next page. And don't forget your 12-Step Challenge—see if you can draw the Brandenburg Gate on page 56!

## Build a scene with the buildings in this chapter!

← →

## HERE'S SOME INSPIRATION

ONCE YOU'VE MASTERED ALL THE BUILDINGS IN THIS CHAPTER, TRY MAKING A SCENE WITH THEM! THIS IS THE FUN PART. I PUT SOME SUGGESTIONS BELOW TO JUMP-START YOUR CREATIVITY. AND DON'T HESITATE TO USE YOUR NEW SKETCH SKILLS TO MODIFY ANY OF THE BUILDINGS HERE. EXPERIMENT WITH THEM IN DIFFERENT ENVIRONMENTS AND COMBINATIONS. THE SKY IS THE LIMIT!

- START WITH THE FIRST SHAPE FAIRLY LARGE IN THE MIDDLE OF THE PAPER SO YOU DON'T RUN OUT OF ROOM ON THE SIDES, TOP, OR BOTTOM WHEN YOU DRAW THE REST OF THE SCENE.

- ADD SOME DETAILS TO THE BUILDING LIKE BRICKS, STONES, SHUTTERS ON THE WINDOWS, AND DOORS FOR THE ENTRANCE.

- WHEN YOU HAVE FINISHED THE BUILDING, ADD SOME NATURE (PAGE 142) AND ADD SOME TREES AROUND YOUR BUILDING.

- HOW DO PEOPLE GET TO THE BUILDING? ADD SOME TRANSPORTATION (PAGE 108) OPTIONS—LIKE A CAR IN FRONT OF THE BUILDING OR A HELICOPTER ABOVE IT. DRAW SOMETHING UNEXPECTED!

- DRAW SOME PEOPLE (PAGE 158) OR DOODLEBUGS (PAGE 76) COMING OUT OF YOUR BUILDING. INVENT A STORY ABOUT THEIR LIVES!

- TRY DRAWING 2 OR 3 DIFFERENT KINDS OF BUILDINGS ON THE SAME PIECE OF PAPER. MAKE A LITTLE NEIGHBORHOOD OF YOUR CONSTRUCTIONS.

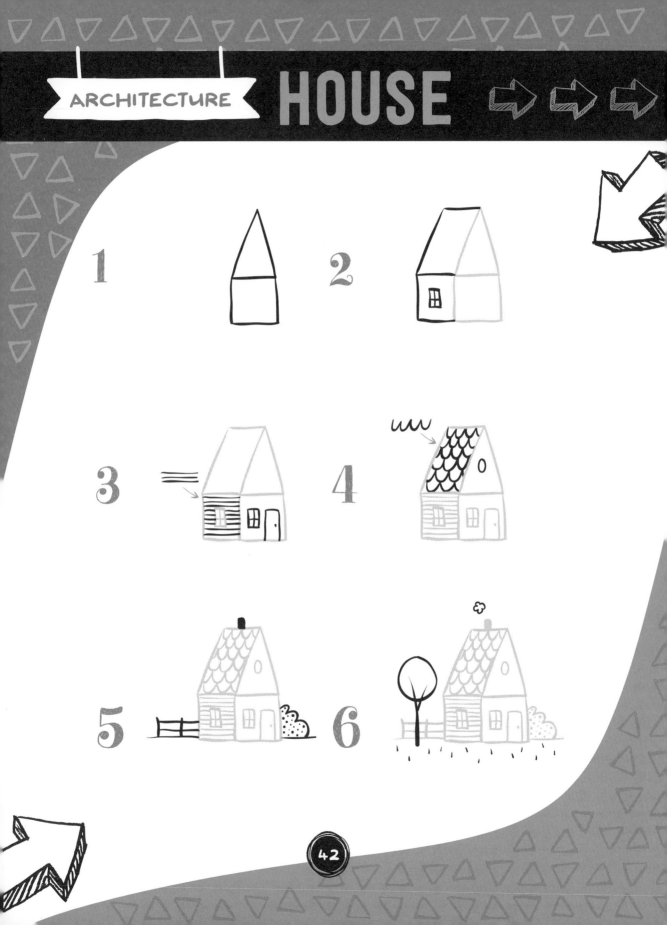

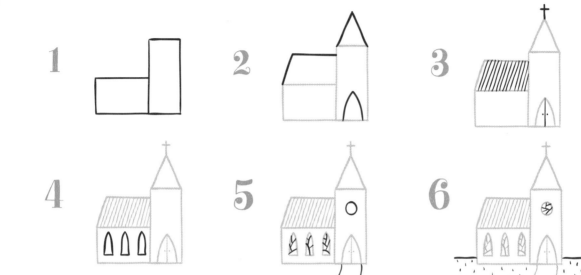

1  2  3

4  5  6

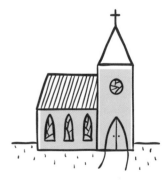

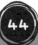

# CASTLE

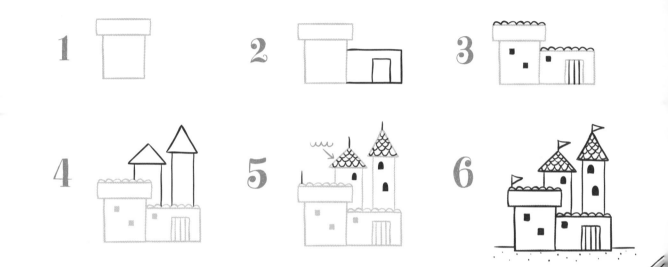

1
2
3
4
5
6

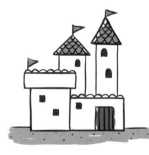

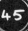

# ARCHITECTURE → TENTS

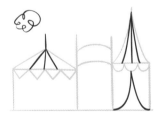

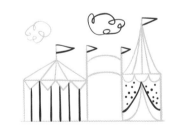

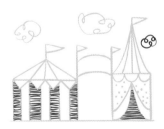

1

2

3

4

5

6

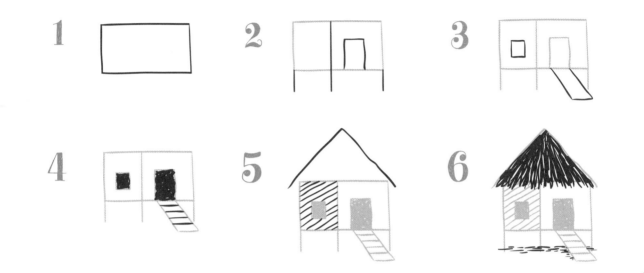

1

2

3

4

5

6

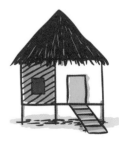

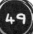

# ARCHITECTURE
## NOTRE DAME

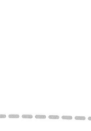

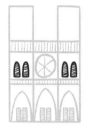

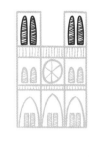

YOUR
TURN!

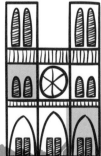

(Practice your new skills in the area above.)

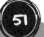

# THE WHITE HOUSE

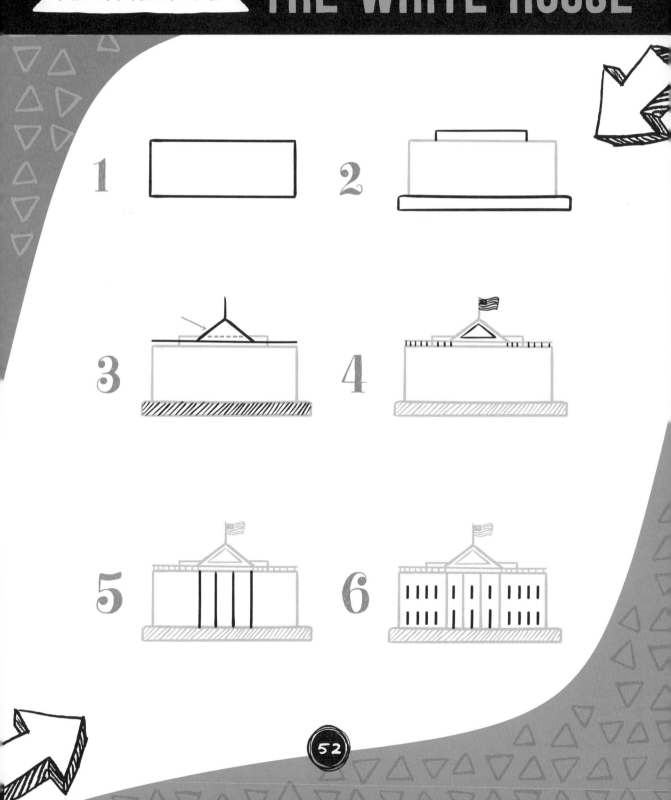

1

2

3

4

5

6

1

2

3

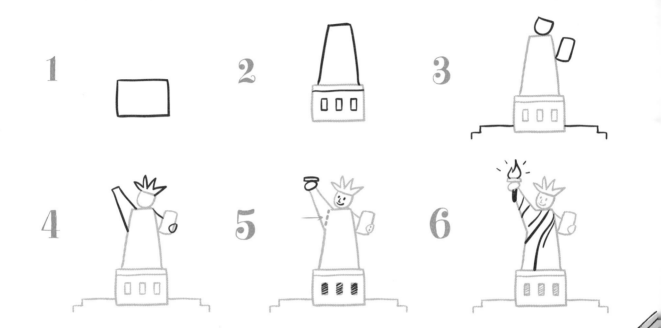

4

5

6

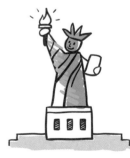

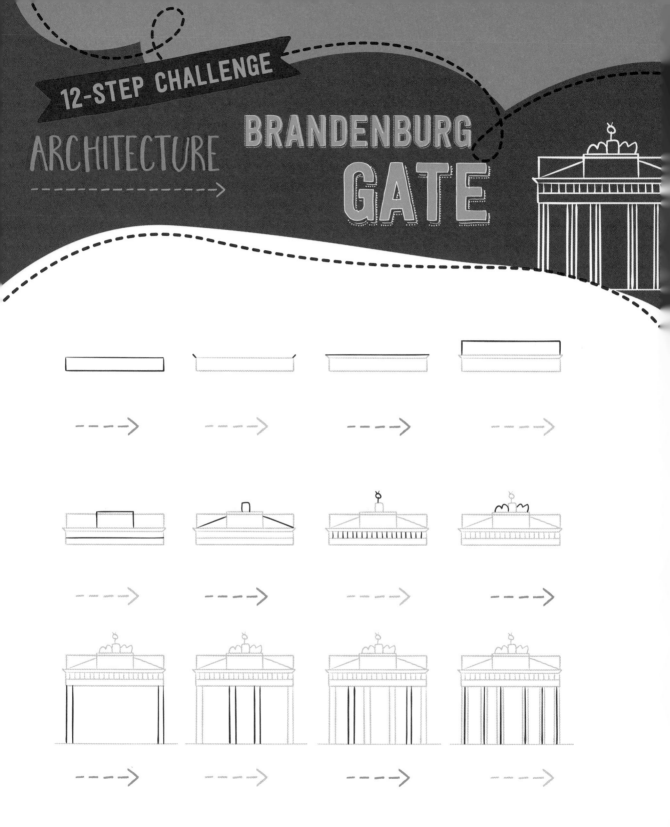

YOUR TURN!

# CHAPTER 4

## DINOSAURS, ALIENS, AND ROBOTS

n this chapter you'll learn how to draw different dinosaurs, aliens, and robots, including a brontosaurus, a T. rex, some aliens, and some robots . . . all in just 6 easy steps! To get even more creative, try some of the suggestions for creating a scene with them on the next page. And don't forget your 12-Step Challenge— see if you can draw the super robot on page 74!

# TRY These TOO!

Dinosaurs, aliens, and robots! Oh my! Create a scene with the dinosaurs, aliens, and robots in this chapter.

## HERE'S SOME INSPIRATION

ONCE YOU'VE MASTERED ALL THE DINOSAURS, ALIENS, AND ROBOTS IN THIS CHAPTER, TRY MAKING A SCENE WITH THEM! THIS IS THE FUN PART. I PUT SOME SUGGESTIONS BELOW TO JUMP-START YOUR CREATIVITY. AND DON'T HESITATE TO USE YOUR NEW SKETCH SKILLS TO MODIFY ANY OF THE CREATURES OR CREATIONS HERE. EXPERIMENT WITH THEM BY ADDING MORE COOL FEATURES. THE SKY IS THE LIMIT!

• DRAW THE BRONTOSAURUS, STEGOSAURUS, AND T. REX IN ONE PICTURE! ADD SOME OTHER UNEXPECTED ELEMENTS, LIKE A BUILDING (PAGE 40). (PUTTING THE DINOSAURS IN THE DOOR OF THE CASTLE MAKES FOR A GREAT STORY!)

• ADD A FUNNY BIRD (PAGE 24) WITH A HAT AS A PASSENGER ON THE BACK OF THE BRONTOSAURUS.

• DRAW A COUPLE OF THE ALIENS ON THE MOON WITH THE AMERICAN FLAG BETWEEN THEM. NAME THE ALIENS AND WRITE A STORY ABOUT HOW THEY GOT THERE!

• SHOW THE ALIEN FAMILY SOMEWHERE UNEXPECTED: EMERGING FROM A BARN (PAGE 48); OBSERVING THE STATUE OF LIBERTY (PAGE 55) FROM AN OCEAN LINER (PAGE 119); OR STANDING ON TOP OF AN AIRPLANE (PAGE 122).

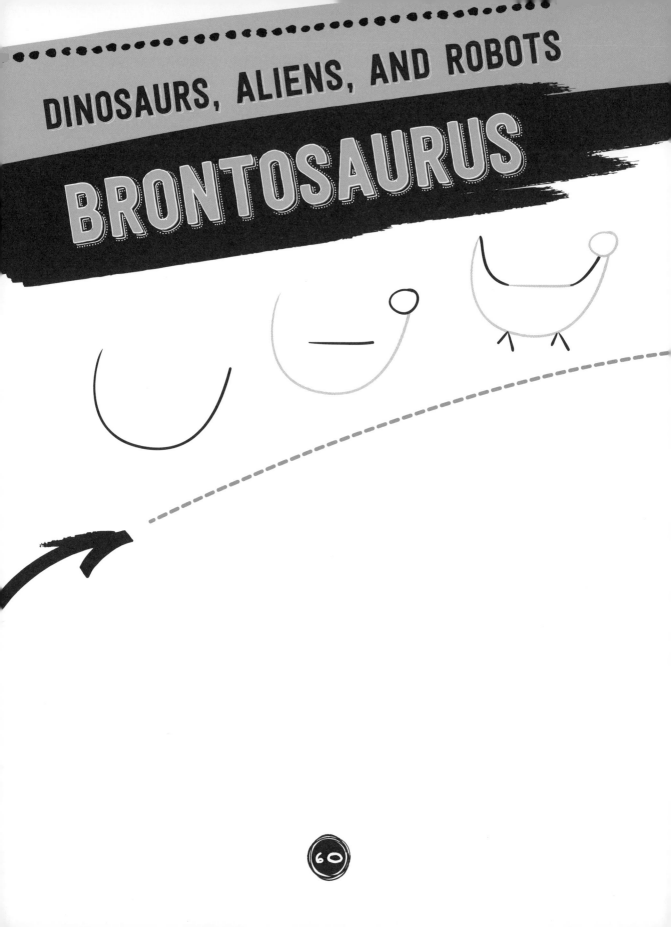

# BRONTOSAURUS

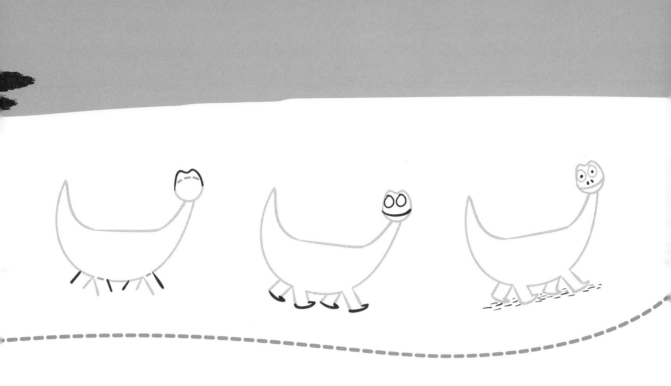

YOUR TURN!

(Practice your new skills in the area above.)

# STEGOSAURUS

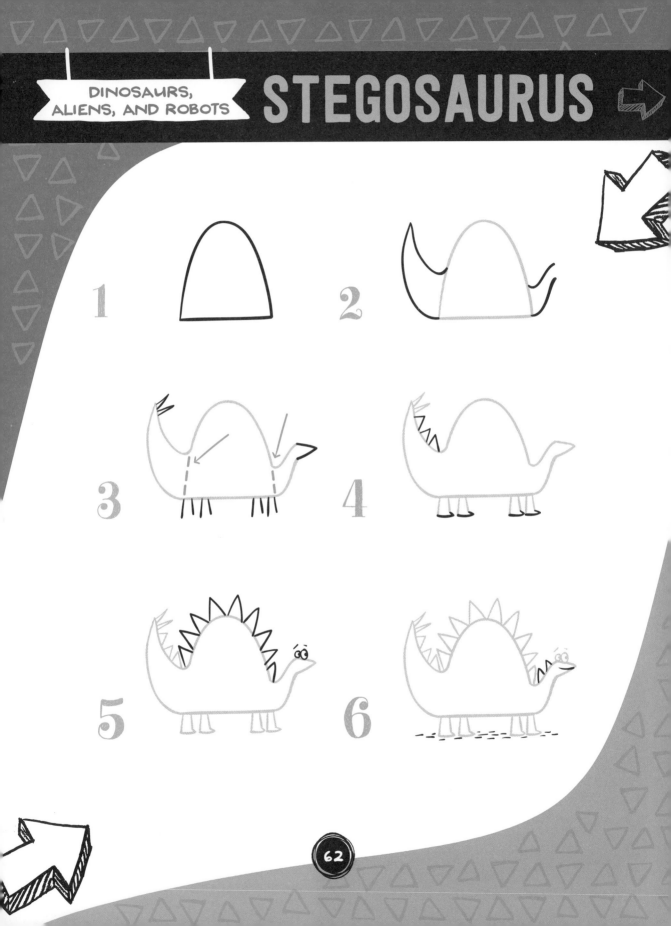

1

2

3

4

5

6

# T. REX

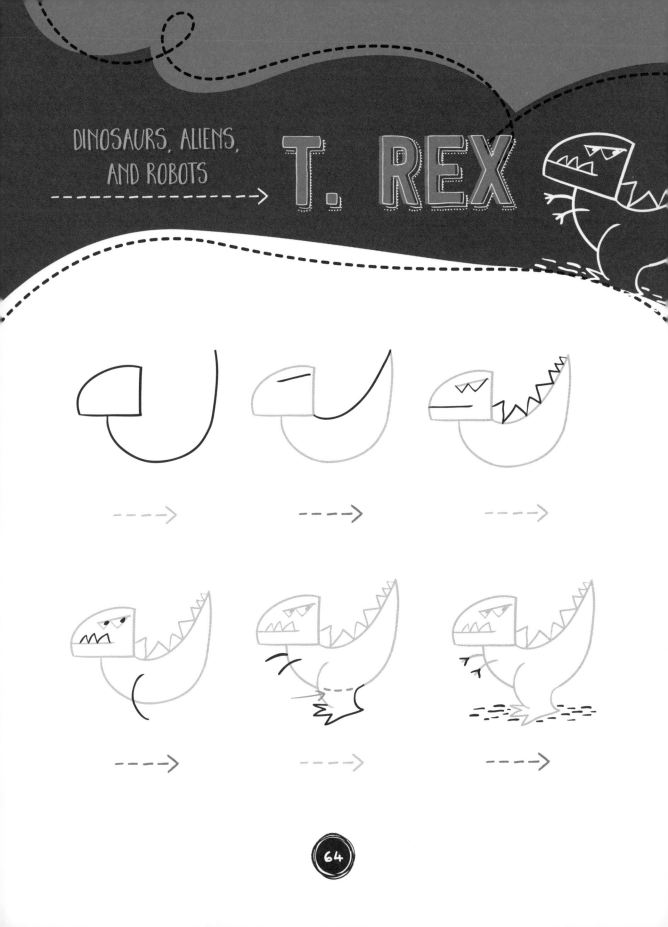

YOUR TURN!

# ALIEN FAMILY

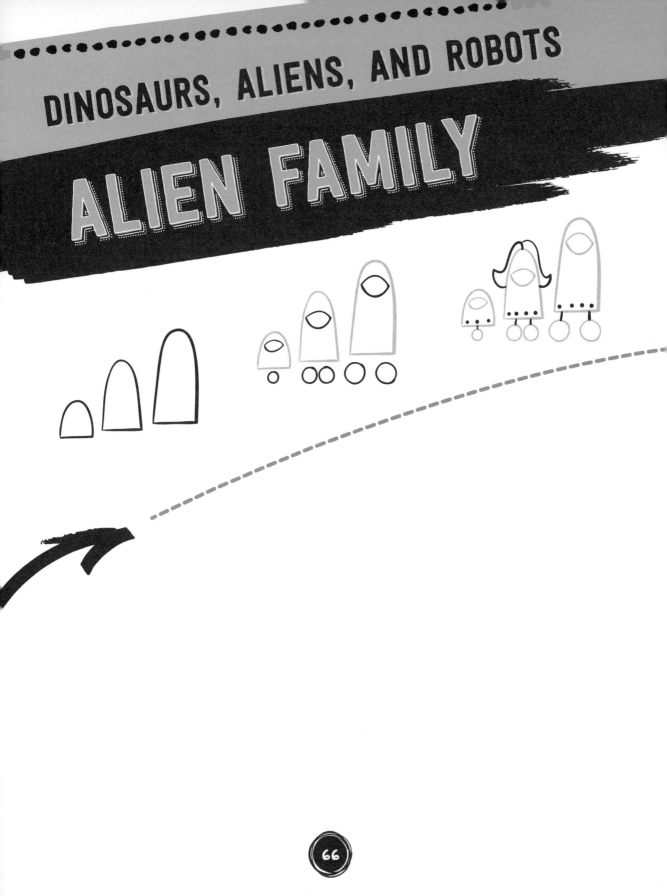

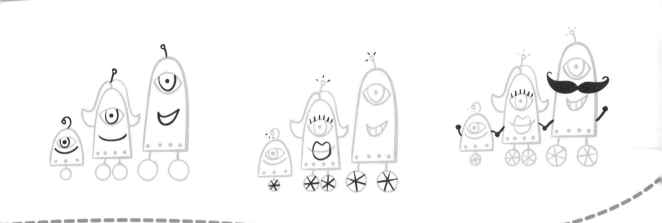

YOUR TURN!

(Practice your new skills in the area above.)

# VORK THE ALIEN

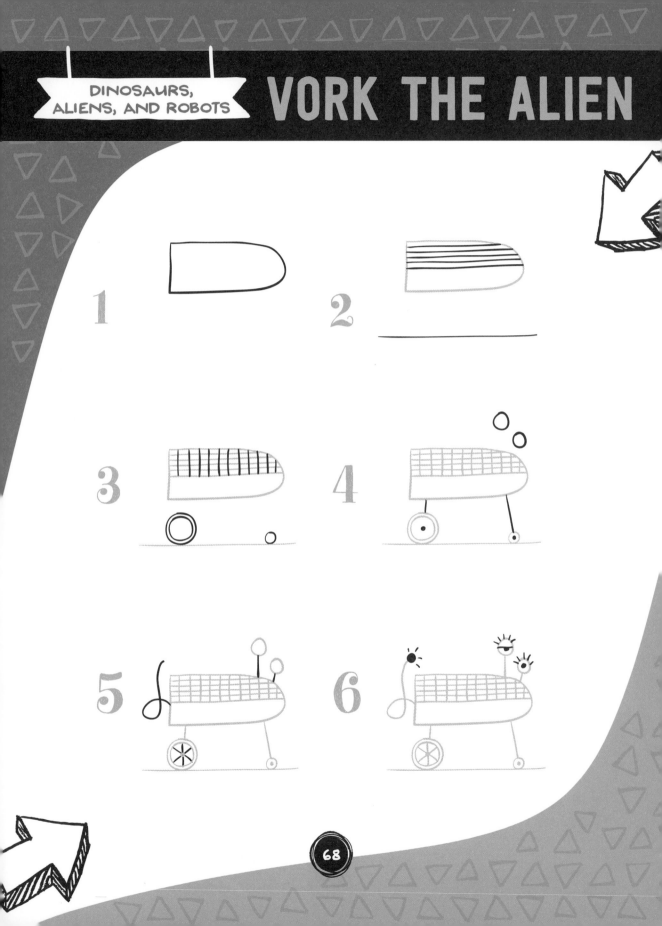

1

2

3

4

5

6

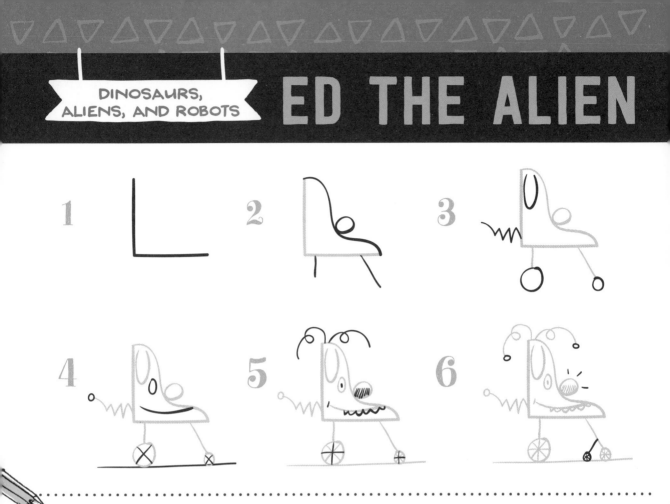

1
2
3
4
5
6

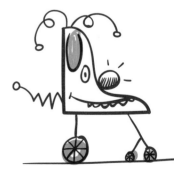

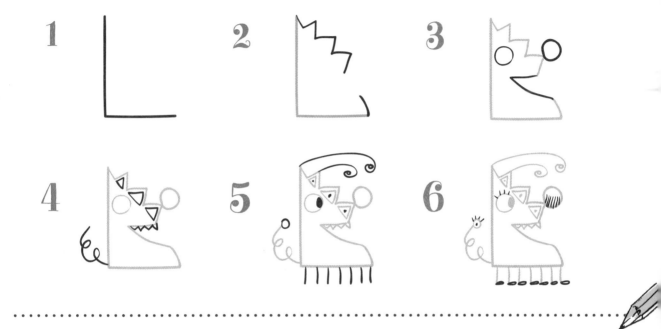

1
2
3
4
5
6

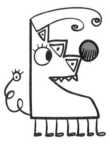

# MR. ROBOT

YOUR TURN!

BEEP!

# SUPER ROBOT

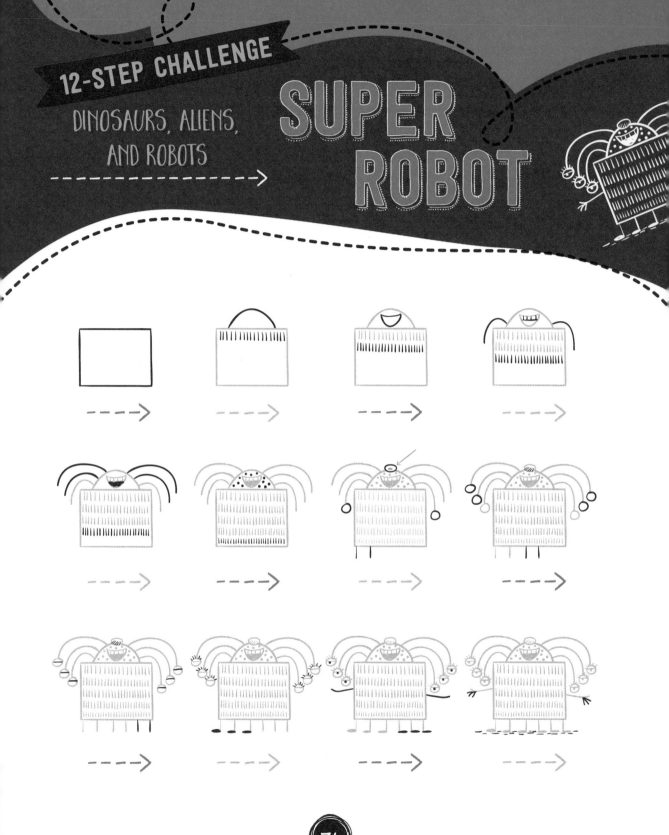

YOUR TURN!

# CHAPTER 5

## DOODLEBUGS

I n this chapter you'll learn how to draw doodlebugs, cute insectoid creations of the imagination . . . all in just 6 easy steps! To get even more creative, try some of the suggestions for creating a scene with them on the next page. And don't forget your 12-Step Challenge—see if you can draw the doodlebug car on page 90!

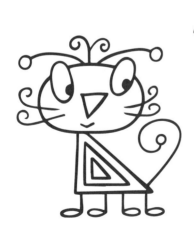

# TRY These TOO!

Create a scene with doodlebugs! Your imagination is the limit.

## HERE'S SOME INSPIRATION

ONCE YOU'VE MASTERED ALL THE DOODLEBUGS IN THIS CHAPTER, TRY MAKING A SCENE WITH THEM! THIS IS THE FUN PART. I PUT SOME SUGGESTIONS BELOW TO JUMP-START YOUR CREATIVITY. AND DON'T HESITATE TO USE YOUR NEW SKETCH SKILLS TO MODIFY ANY OF THE CREATURES HERE. EXPERIMENT WITH THEM BY USING OTHER SHAPES, OR HAVE THEM DO "PEOPLE" THINGS LIKE EAT PIZZA OR WEAR CLOTHES. THE SKY IS THE LIMIT!

- DRAW A SCENE WITH SOME DOODLEBUGS DOING THINGS ON GIANT FLOWERS, PARACHUTING DOWN FROM AN AIRPLANE, RIDING A SKATEBOARD, OR PEEKING OUT FROM BEHIND A LEAF.

- USE YOUR IMAGINATION TO DRAW A FUN PLACE FOR YOUR DOODLEBUGS TO LIVE AND PLAY.

- DRAW THE 12-STEP DOODLEBUG DRIVING THE CAR DOWN THE SIDE OF AN EXPLODING VOLCANO. WRITE A STORY ABOUT IT. HOW DID THE DOODLEBUG GET THERE?

- MAKE UP YOUR OWN DOODLEBUGS! YOUR IMAGINATION IS THE ONLY LIMIT ON THESE IMAGINARY CREATIONS.

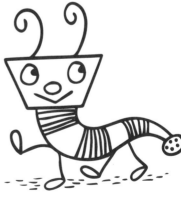

# DOODLEBUGS

## DENNY

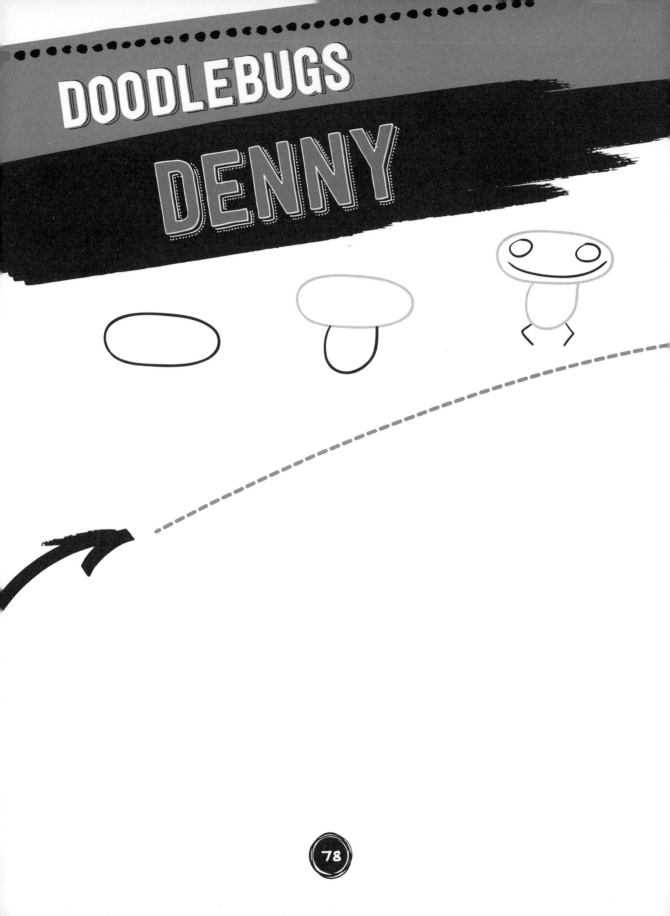

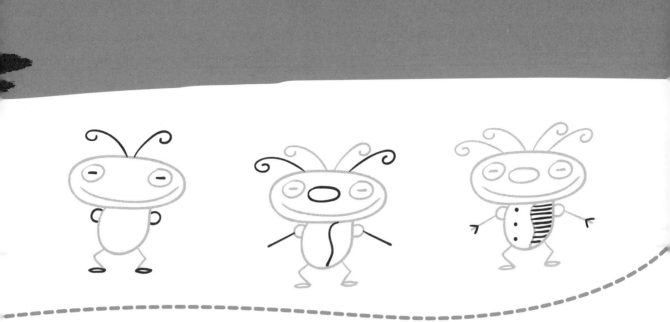

YOUR TURN!

(Practice your new skills in the area above.)

79

1

2

3

4

5

6

1

2

3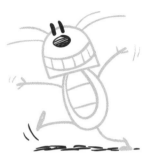

4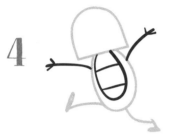

5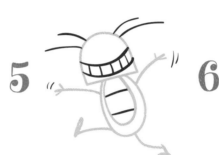

6

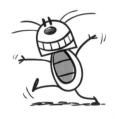

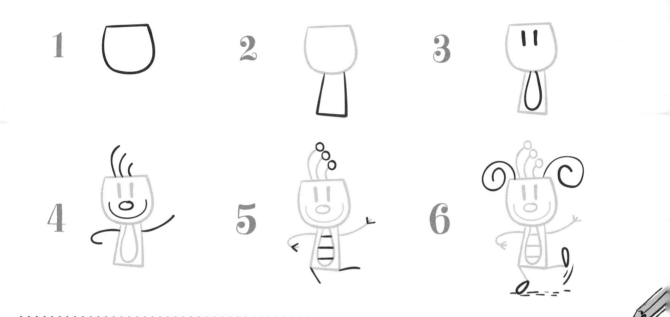

1  2  3

4  5  6

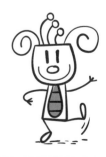

YOUR TURN!

# DOODLEBUGS

## LUMBARDO

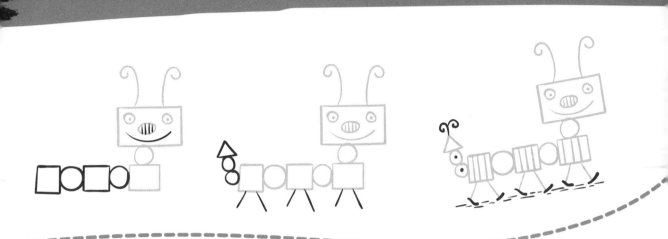

YOUR TURN!

(Practice your new skills in the area above.)

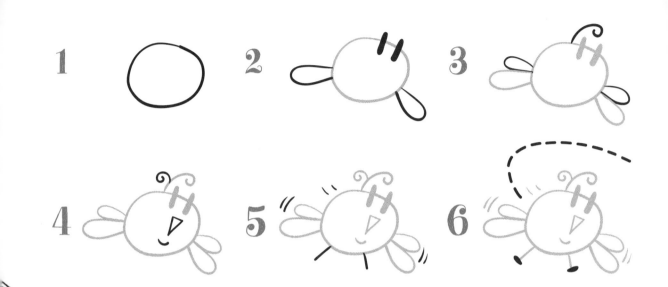

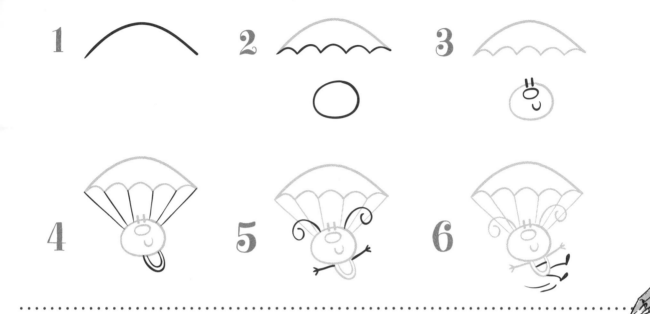

1 2 3

4 5 6

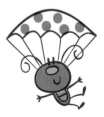

YOUR TURN!

# CHAPTER 6

## FISH

In this chapter you'll learn how to draw various fish . . . all in just 6 easy steps! To get even more creative, try some of the suggestions for creating a scene with them on the next page. And don't forget your 12-Step Challenge—see if you can draw the angelfish on page 106!

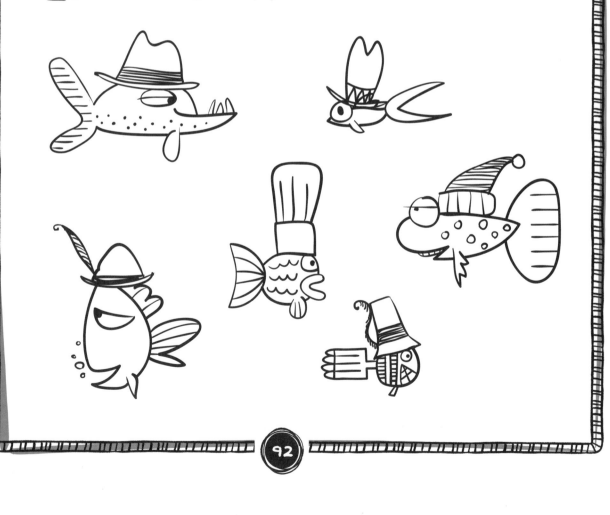

# TRY These TOO!

## Create a school of fish from the drawings in this chapter.

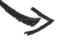

## HERE'S SOME INSPIRATION

ONCE YOU'VE MASTERED ALL THE FISH IN THIS CHAPTER, TRY MAKING A SCENE WITH THEM! THIS IS THE FUN PART. I PUT SOME SUGGESTIONS BELOW TO JUMP-START YOUR CREATIVITY. AND DON'T HESITATE TO USE YOUR NEW SKETCH SKILLS TO MODIFY ANY OF THE CREATURES HERE OR CREATE AN ENTIRELY NEW FISH. EXPERIMENT WITH THEM IN DIFFERENT PLACES OR EVEN HAVE THEM DO "PEOPLE" THINGS. THE SKY IS THE LIMIT!

- DRAW THE 12-STEP FISH LARGE, TO FILL UP A LOT OF THE SCENE. SURROUND IT WITH SOME OTHER, SMALLER FISH FROM THE CHAPTER. ADD SOME THOUGHT BUBBLES TO SHOW WHAT THEY ARE THINKING!

- DRAW YOUR OWN, UNIQUE FISH BY CHOOSING SOME DIFFERENT SHAPES TO START WITH. THEN, ADD EYES, A MOUTH, AND FINS. TRY DRAWING THE EYES LARGE AND THE MOUTH SMALL OR VICE VERSA TO SEE HOW THAT CHANGES THE APPEARANCE. DON'T FORGET TO GIVE YOUR FISH A NAME!

- DRAW ANY 3 FISH FROM THIS CHAPTER. ADD A HAT (PAGE 159) TO EACH FISH TO MAKE A COMICAL SCENE!

- DRAW A SUBMARINE (PAGE 116) AND THEN SOME FISH AROUND IT LOOKING INTO THE WINDOWS. DRAW THE FACES OF DOODLEBUGS OR PEOPLE LOOKING OUT THE WINDOWS AT THE FISH.

- DRAW AN OLD VIKING SHIP (PAGE 118) SUNK AT THE BOTTOM OF THE OCEAN. ADD SOME UNEXPECTED THINGS AROUND IT AND THEN DRAW SOME FISH LOOKING AT THE SCENE WITH SURPRISED FACES.

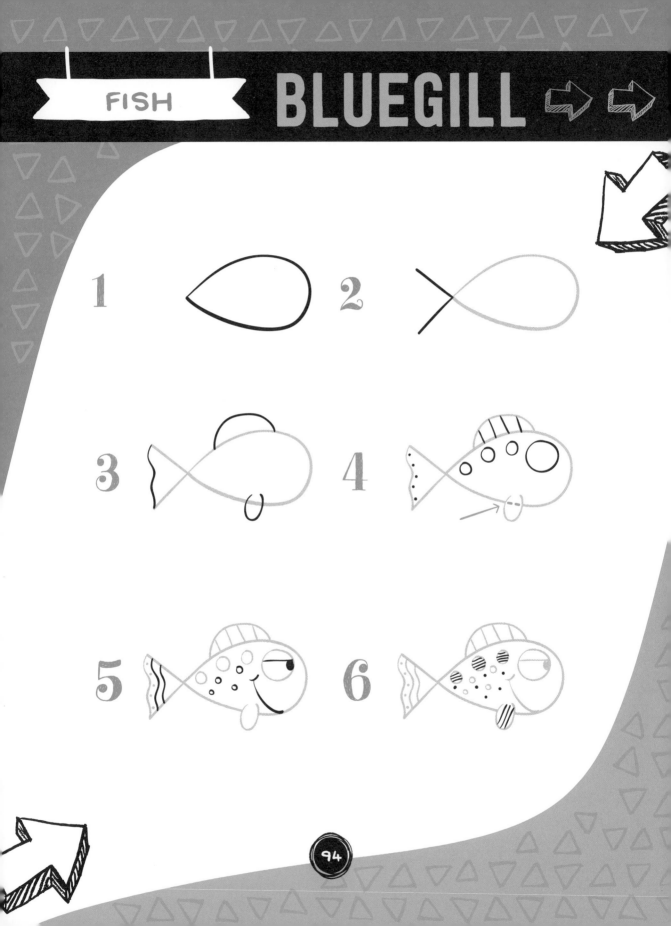

1

2

3

4

5

6

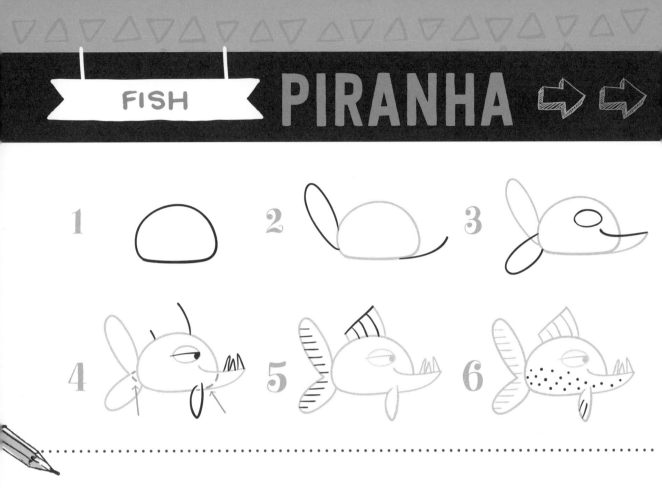

1

2

3

4

5

6

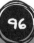

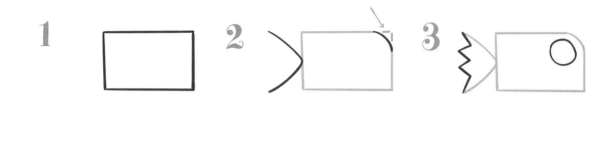

**1** **2** **3**

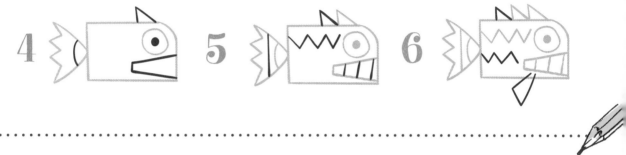

**4** **5** **6**

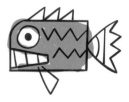

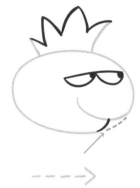

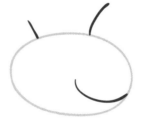

YOUR TURN!

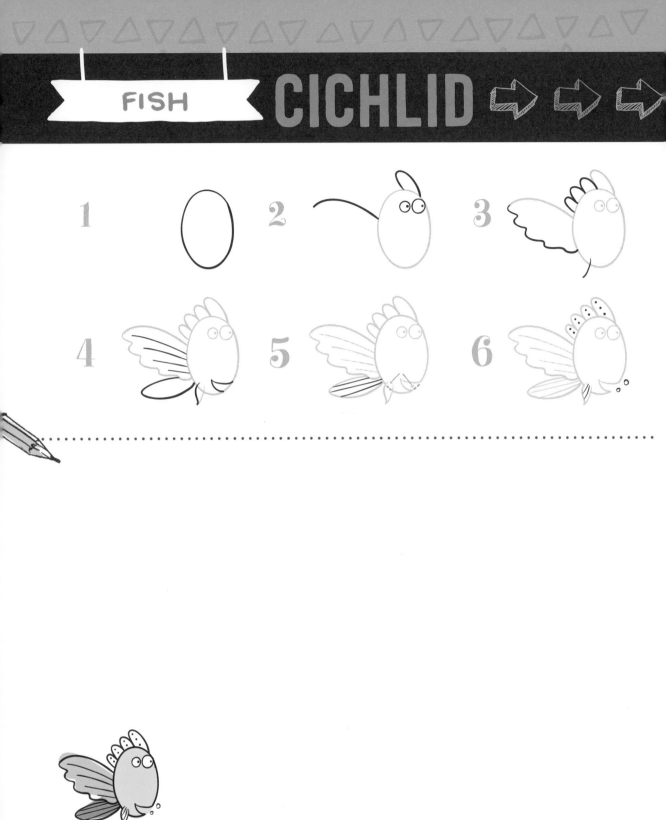

1

2

3

4

5

6

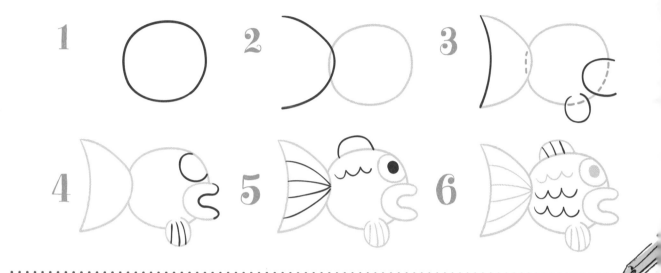

1   2   3

4   5   6

# FISH

# UNIQUE FISH

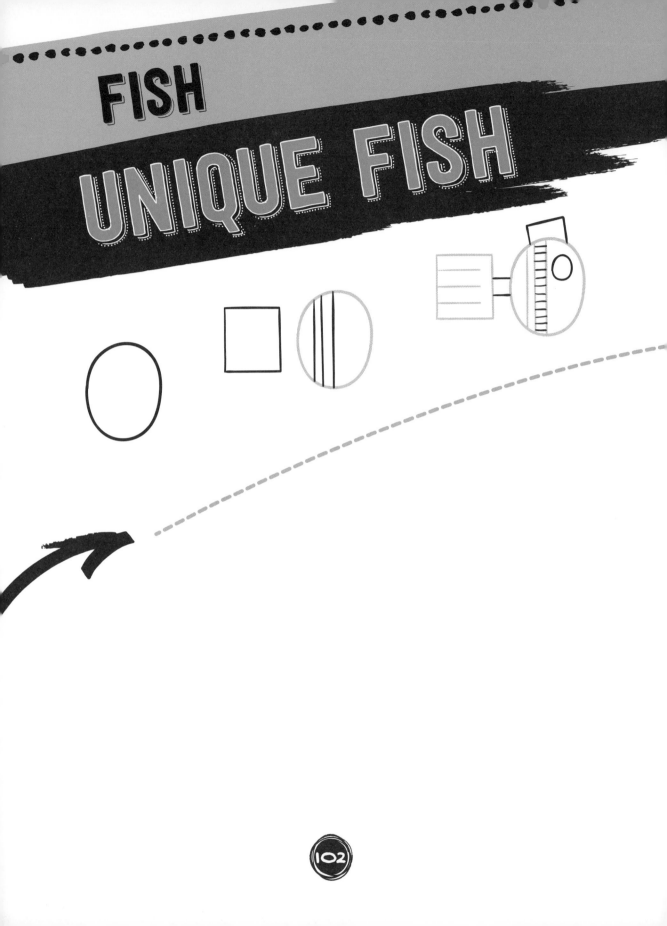

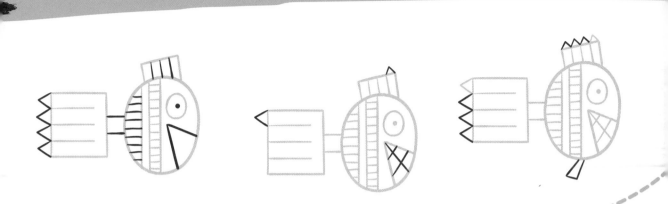

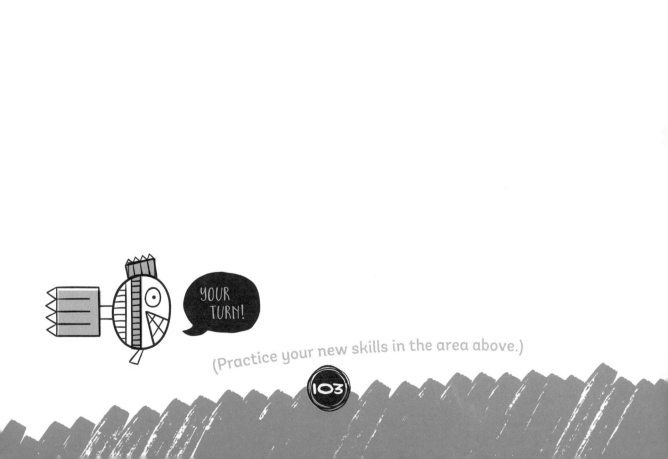

YOUR TURN!

(Practice your new skills in the area above.)

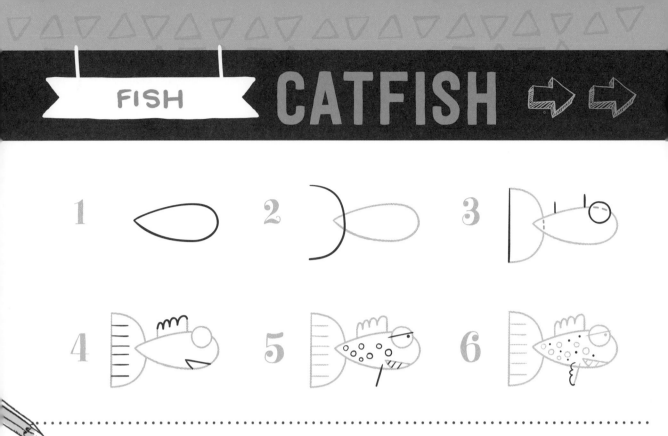

1
2
3
4
5
6

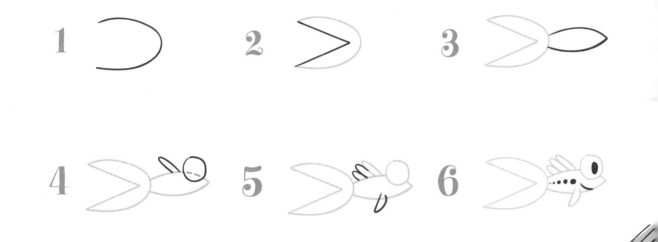

1  2  3

4  5  6

# FISH → ANGELFISH

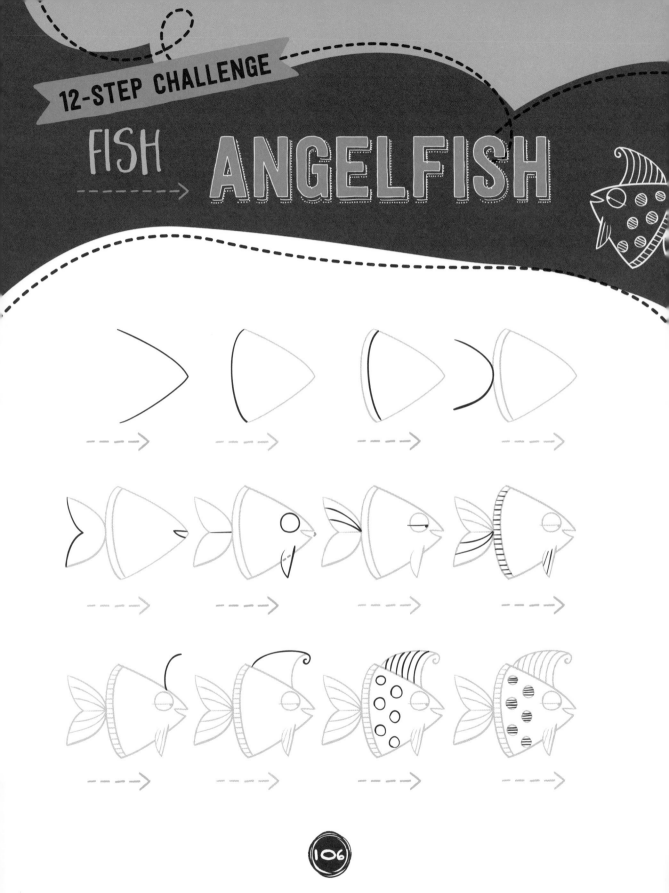

YOUR TURN!

# CHAPTER 7

## TRANSPORTATION

In this chapter you'll learn how to draw some common and uncommon modes of transportation, from cars to airplanes to boats . . . all in just 6 easy steps! To get even more creative, try some of the suggestions for creating a scene with them on the next page. And don't forget your 12-Step Challenge—see if you can draw the convertible on page 124!

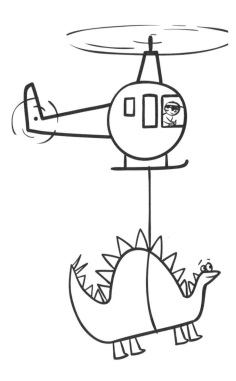

# TRY These TOO!

Your towns and people need ways to get around! Add some common (and uncommon!) modes of transportation to your scenes.

## HERE'S SOME INSPIRATION

ONCE YOU'VE MASTERED ALL THE MODES OF TRANSPORTATION IN THIS CHAPTER, TRY MAKING A SCENE WITH THEM! THIS IS THE FUN PART. I PUT SOME SUGGESTIONS BELOW TO JUMP-START YOUR CREATIVITY. AND DON'T HESITATE TO USE YOUR NEW SKETCH SKILLS TO MODIFY ANY OF THE VEHICLES HERE. EXPERIMENT WITH DIFFERENT DRIVERS, PASSENGERS, AND LOCATIONS. HAVE FUN! THE SKY IS THE LIMIT!

- VEHICLES ARE USUALLY MOVING. DON'T FORGET TO DRAW LITTLE LINES BEHIND THEM SHOWING HOW FAST THEY ARE GOING. FOR VEHICLES THAT ARE STOPPED (LIKE A CAR AT A TRAFFIC LIGHT) DON'T ADD THESE LINES.

- LOOK AT THE SHAPES OF THE CARS. EXPERIMENT WITH DIFFERENT SHAPES TO CREATE A NEW CAR! YOUR IMAGINATION IS THE ONLY LIMIT.

- RUNAWAY VEHICLES! MOST OF THE THINGS IN THIS CHAPTER DON'T HAVE ANYBODY DRIVING THEM. DRAW A CHARACTER INTO THE DRIVER'S SEAT SO THAT THERE IS SOMEONE IN CONTROL OF THE VEHICLE.

- DRAW THE HELICOPTER FLYING, WITH A ROPE HANGING DOWN CARRYING SOMETHING UNEXPECTED. MAYBE IT'S CARRYING A PERSON OR A FISH? OR POSSIBLY A BUILDING OR AN EXPLODING VOLCANO! WRITE A STORY ABOUT YOUR PICTURE EXPLAINING HOW ALL OF THESE ELEMENTS CAME TOGETHER.

- TRY PUTTING BIG WHEELS ON A VEHICLE INSTEAD OF SMALL WHEELS. THIS ALLOWS CARS AND TRUCKS TO BE HIGHER OFF THE GROUND AND PASS OVER OBSTACLES EASIER.

# BICYCLE

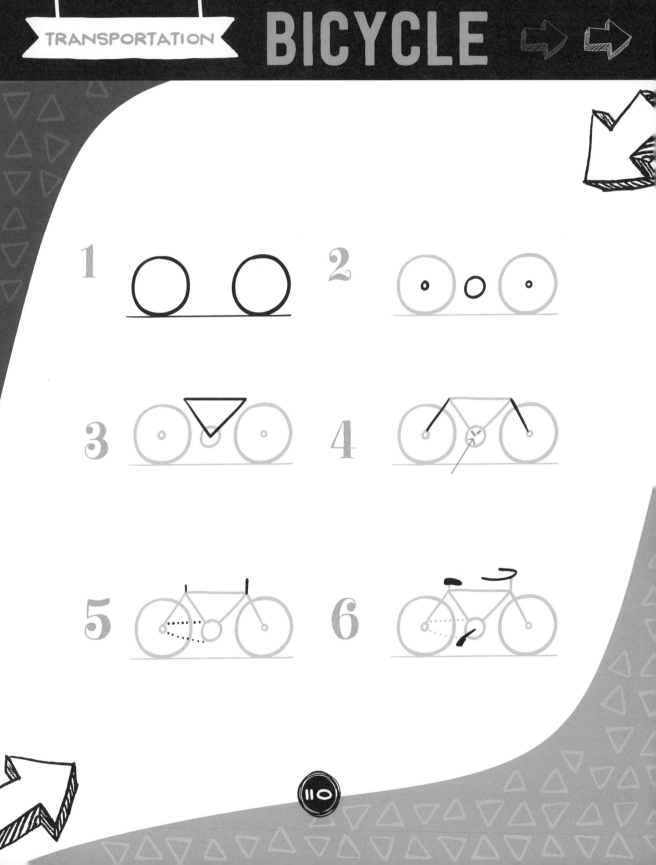

1

2

3

4

5

6

# TRACTOR

YOUR TURN!

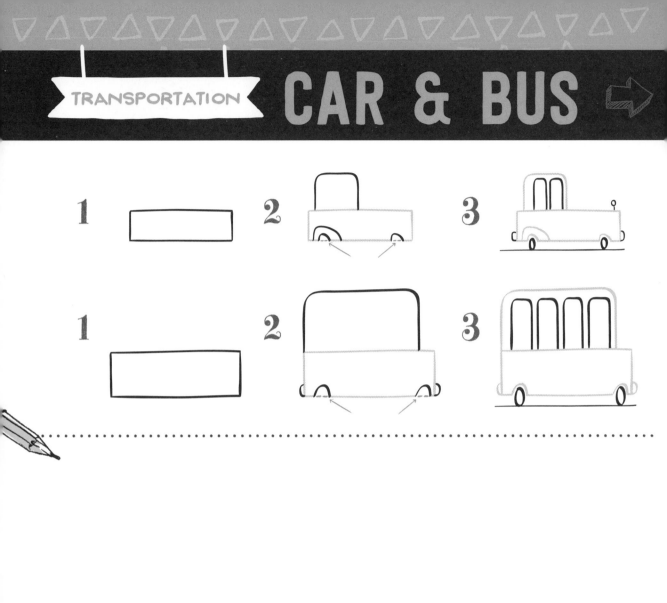

1

2

3

1

2

3

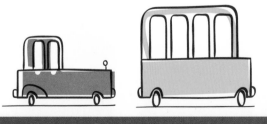

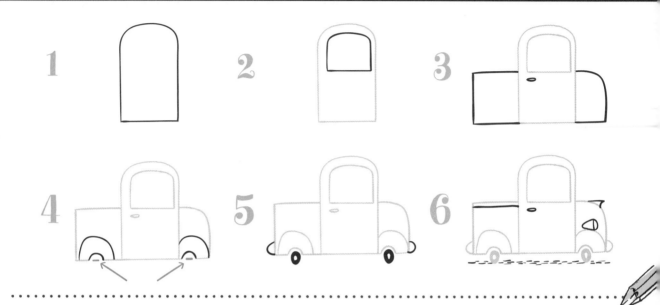

1

2

3

4

5

6

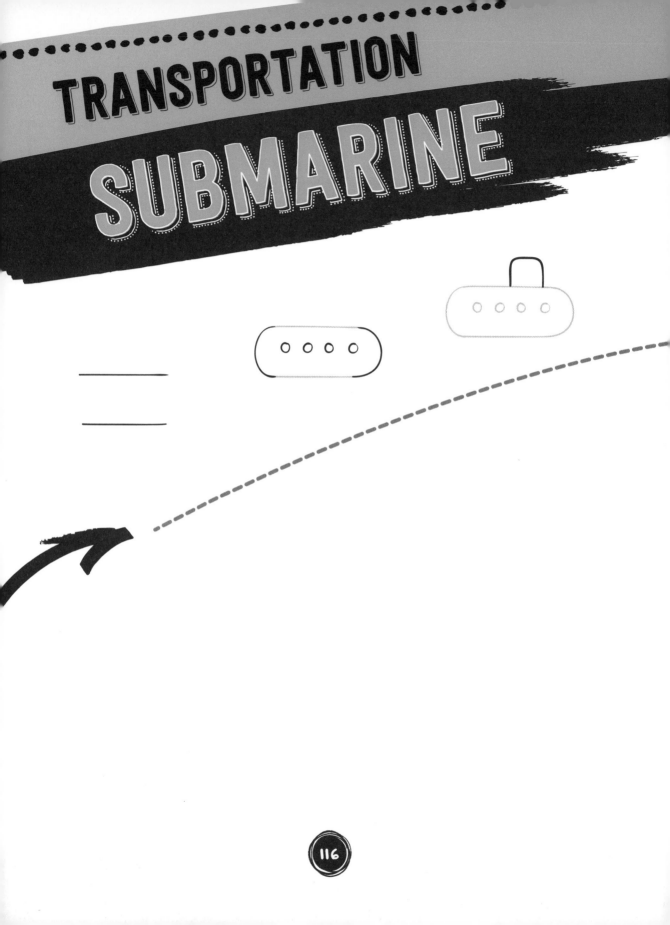

# TRANSPORTATION

# SUBMARINE

YOUR TURN!

(Practice your new skills in the area above.)

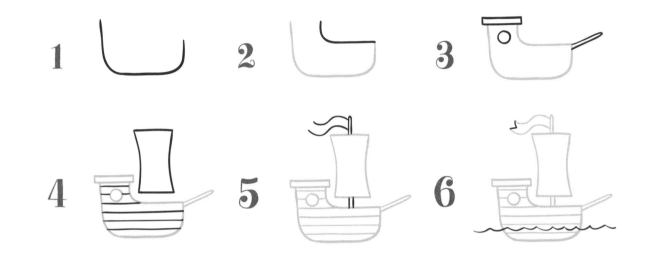

1

2

3

4

5

6

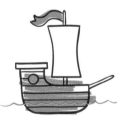

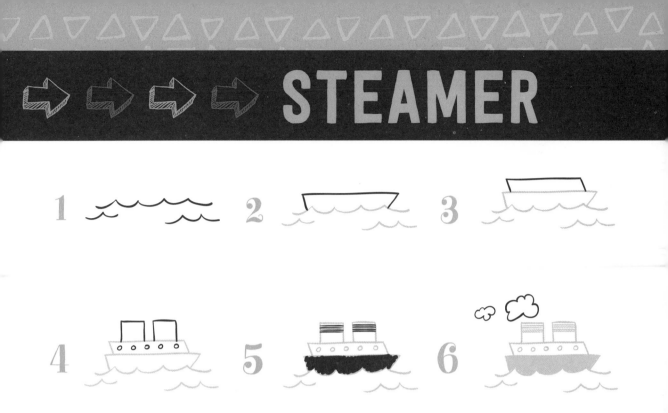

1 2 3

4 5 6

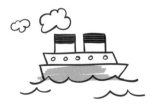

1

2

3

4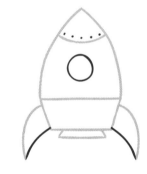

5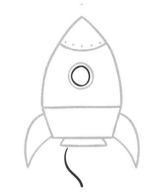

6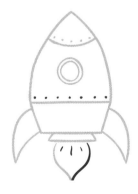

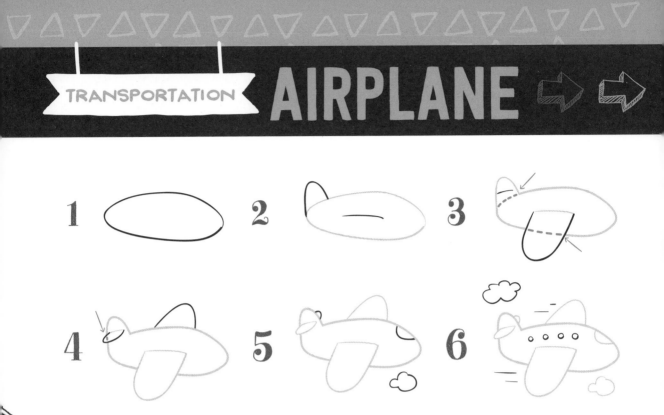

1

2

3

4

5

6

1

2

3

4

5

6

TRANSPORTATION → CONVERTIBLE

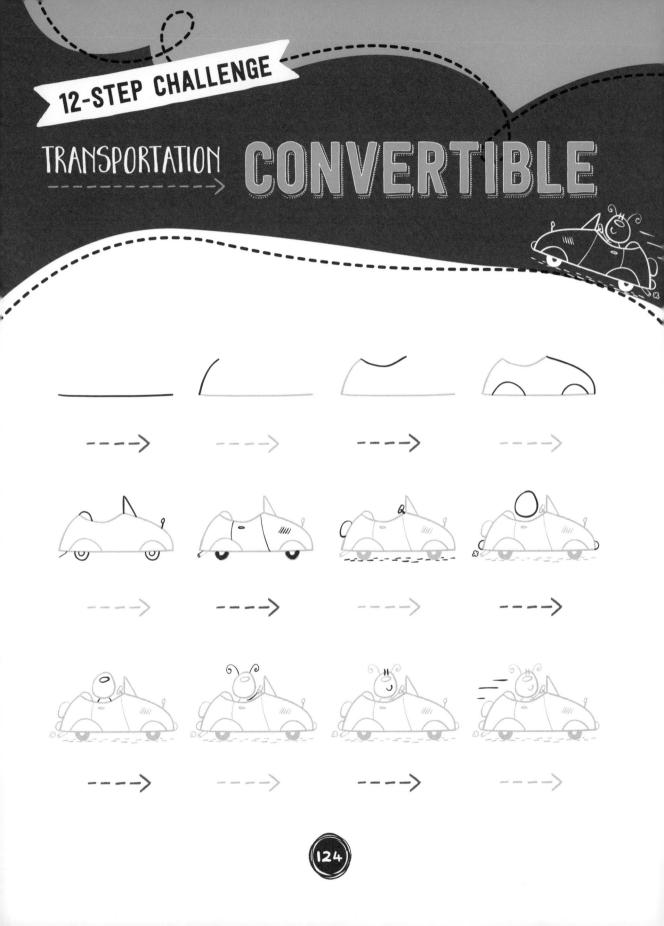

YOUR TURN!

125

# CHAPTER 8

## GARDEN

In this chapter you'll learn how to draw the different things found in the garden . . . all in just 6 easy steps! To get even more creative, try some of the suggestions for creating a scene with them on the next page. And don't forget your 12-Step Challenge—see if you can draw the gardener on page 140!

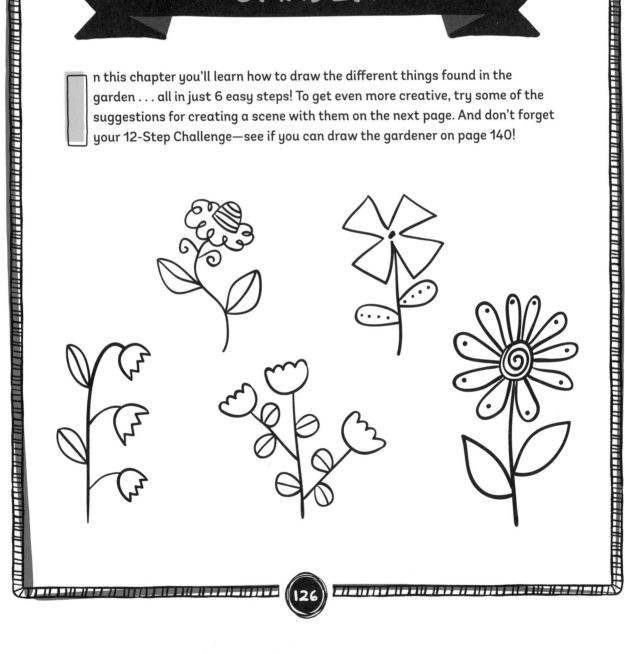

The garden is a serene place to gather one's thoughts. Create a scene with some of the calming elements in this chapter.

## HERE'S SOME INSPIRATION

ONCE YOU'VE MASTERED ALL THE THINGS THAT GO IN THE GARDEN, TRY MAKING A SCENE WITH THEM! THIS IS THE FUN PART. I PUT SOME SUGGESTIONS BELOW TO JUMP-START YOUR CREATIVITY. AND DON'T HESITATE TO USE YOUR NEW SKETCH SKILLS TO MODIFY ANY OF THE THINGS HERE. EXPERIMENT WITH DIFFERENT FLOWERS, PLANTS, INSECTS, AND GARDENERS. THE SKY IS THE LIMIT!

- DRAW THE ROW OF FLOWERS AND THEN ADD SOME DRAGONFLIES AND BUTTERFLIES FLYING AROUND THEM. ADD SOME CHARACTERS ENJOYING THE BEAUTIFUL DAY IN A SERENE PARK!

- SKETCH THE 3 POTTED FLOWERS AND THEN DRAW THE WATERING CAN WATERING THE POTS. WHO IS HOLDING THE WATERING CAN?

- DRAW A HOUSE AND THEN ADD SOME FLOWERS TO THE GARDEN AROUND IT. WHO LIVES IN THE HOUSE? DO THEY TAKE CARE OF THE GARDEN AND LAWN? WRITE A STORY ABOUT THEM!

# POTTED FLOWERS

**1**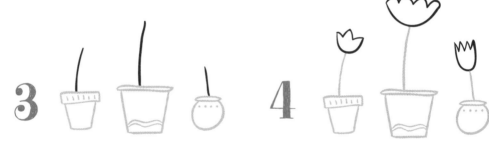

**2**

**3**

**4**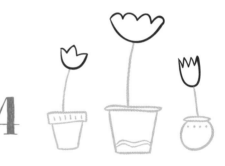

**5**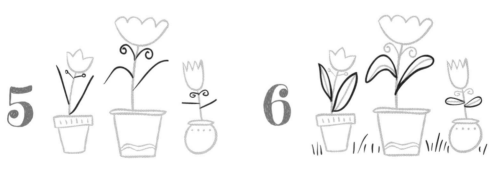

**6**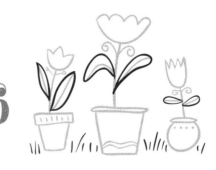

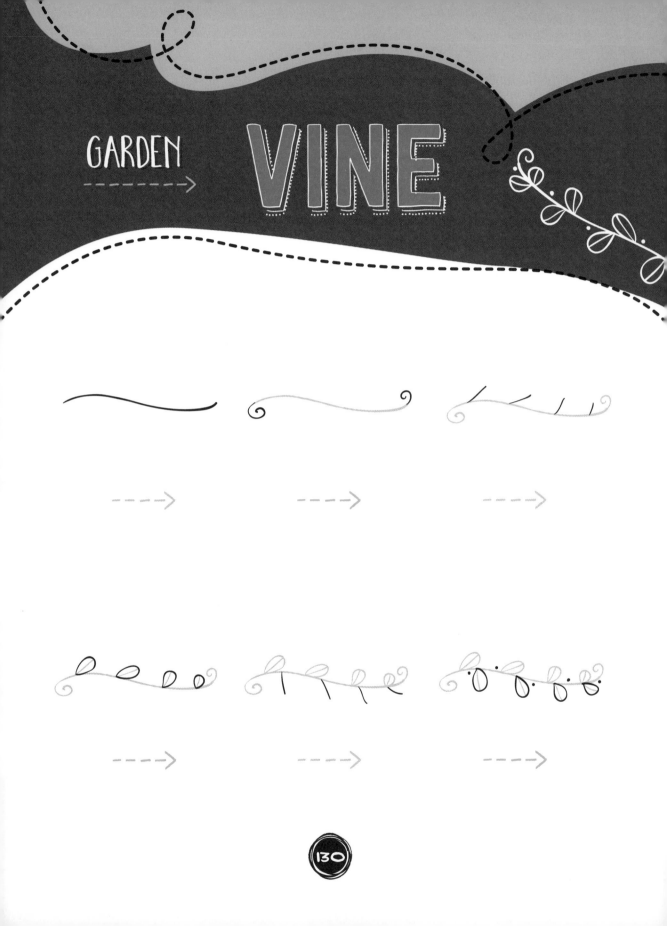

YOUR TURN!

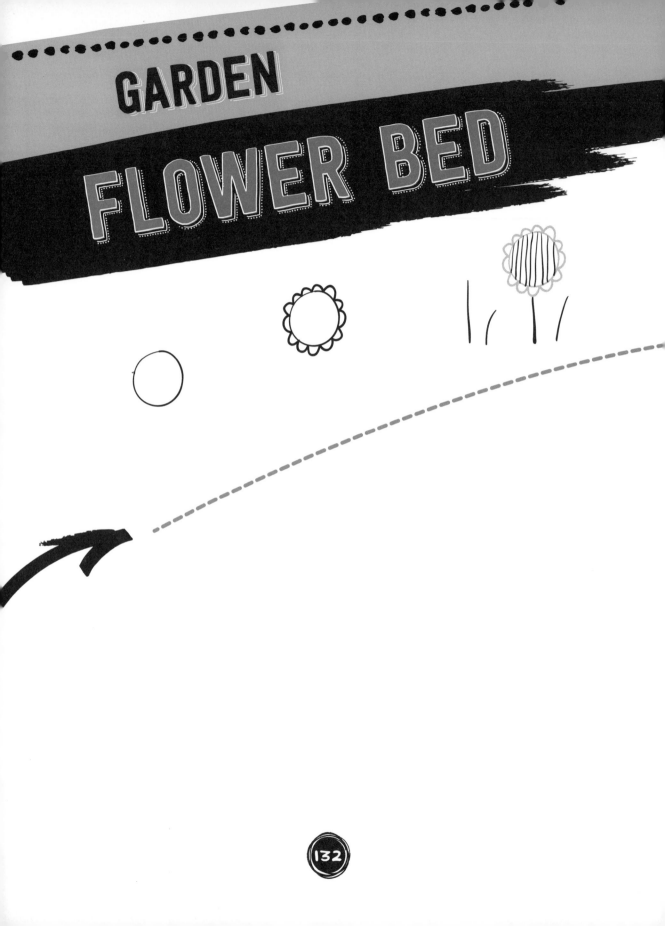

# GARDEN
# FLOWER BED

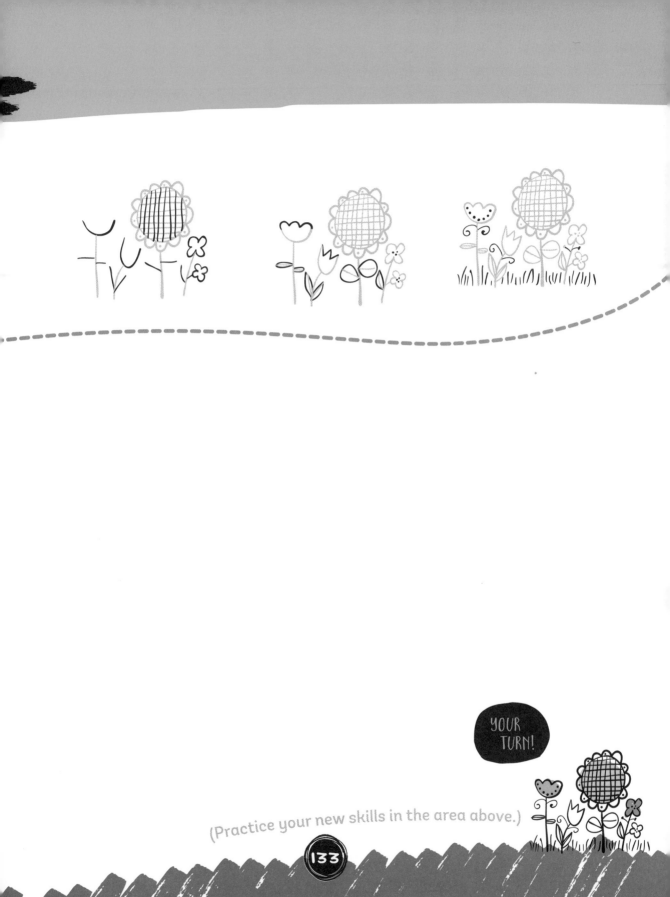

YOUR TURN!

(Practice your new skills in the area above.)

# WATERING CAN

**1**

**2**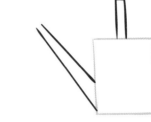

**3**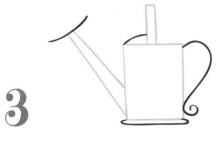

**4**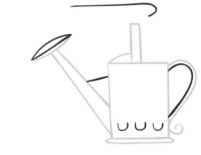

**5**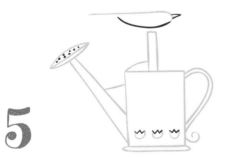

**6**

# GARDEN → GRASSHOPPER

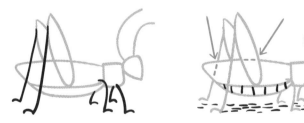

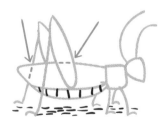

YOUR TURN!

# DRAGONFLY

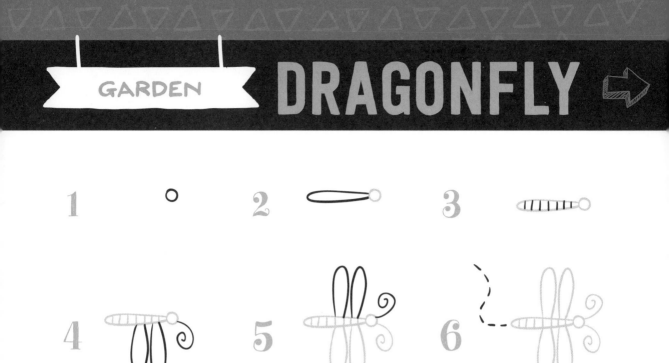

1

2

3

4

5

6

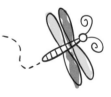

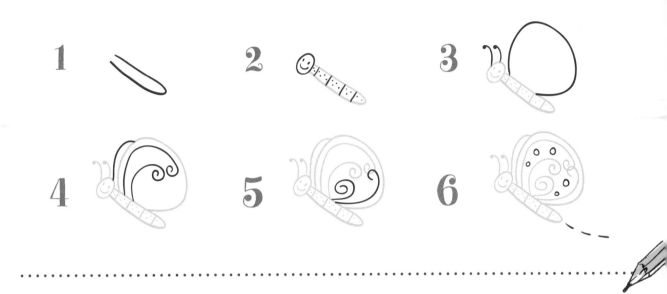

1

2

3

4

5

6

# GARDEN -----> PIG GARDENER

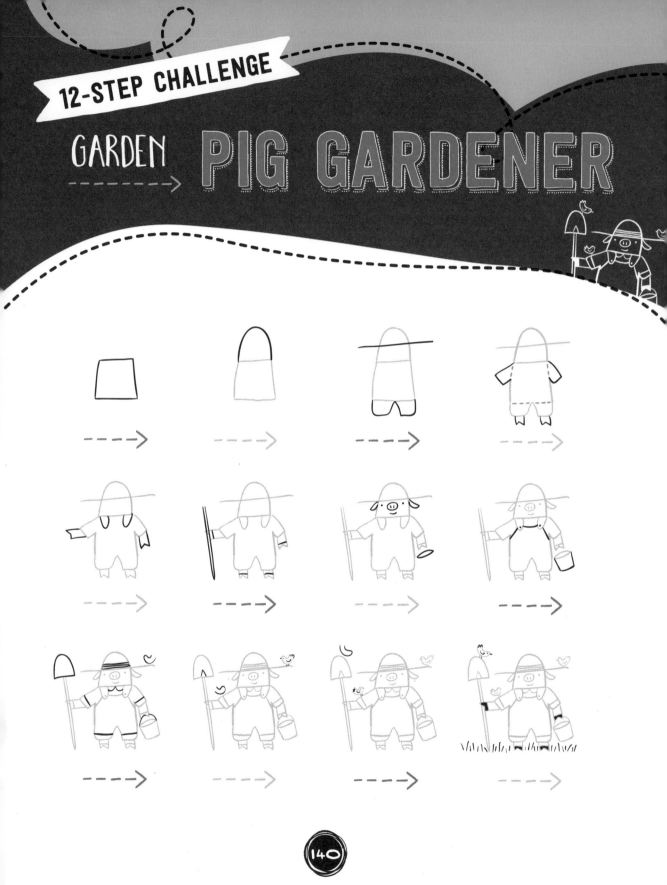

YOUR TURN!

# CHAPTER 9

## GREAT OUTDOORS

I n this chapter you'll learn how to draw things found in the great outdoors . . . all in just 6 easy steps! To get even more creative, try some of the suggestions for creating a scene with them on the next page. And don't forget your 12-Step Challenge—see if you can draw the baobab tree on page 156!

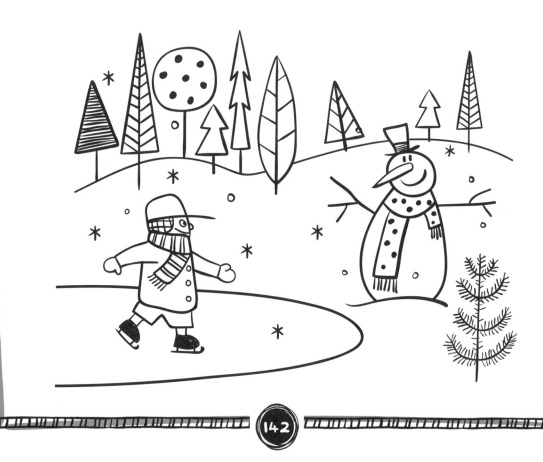

# TRY These TOO!

## Make a nature scene using the elements in this chapter.

### HERE'S SOME INSPIRATION

ONCE YOU'VE MASTERED ALL THE THINGS FOUND IN THE GREAT OUTDOORS, TRY MAKING A SCENE WITH THEM! THIS IS THE FUN PART. I PUT SOME SUGGESTIONS BELOW TO JUMP-START YOUR CREATIVITY. AND DON'T HESITATE TO USE YOUR NEW SKETCH SKILLS TO MODIFY ANY OF THE THINGS HERE. EXPERIMENT WITH DIFFERENT SEASONS AND PERSPECTIVES! FILL YOUR SCENES WITH QUIRKY COMBINATIONS FROM THIS-AND OTHER-CHAPTERS. THE SKY IS THE LIMIT!

- SEE IF YOU CAN COMBINE SEVERAL DIFFERENT THINGS FROM THIS CHAPTER INTO 1 IMAGE. PERHAPS DRAW A MOUNTAINSIDE WITH TREES ON IT? OR A FOREST OF MANY DIFFERENT KINDS OF TREES.

- DRAW A SNOWMAN STANDING SOMEPLACE UNEXPECTED, SUCH AS NEXT TO THE STATUE OF LIBERTY (PAGE 55). DRAW A SHIP (PAGE 119) GOING PAST THE STATUE AND SNOWMAN. WRITE A STORY ABOUT HOW THE SNOWMAN ENDED UP NEXT TO THE STATUE OF LIBERTY!

- PLAY WITH PERSPECTIVE! DRAW SOME TREES LARGE AND THEN A LINE AND PUT SMALLER TREES ON THE LINE. NOTICE THAT THE TREES CLOSE UP ARE LARGER AND THE ONES FURTHER AWAY ARE SMALLER.

- DRAW A MOUNTAIN RANGE AND THEN ADD A JET FLYING FAR ABOVE IT. DRAW A PARACHUTING DOODLEBUG DROPPING DOWN FROM THE JET. DRAW A SPEECH BUBBLE AND FILL IT IN WITH WHAT THE DOODLEBUG IS SAYING.

- EXPERIMENT WITH MAKING SOME OF YOUR OWN TREES. REMEMBER TO START WITH A BIG, SIMPLE SHAPE FIRST AND THEN ADD TO IT. IF IT LOOKS LIKE NO EARTHLY TREE, DRAW SOME ALIENS AROUND IT AND CREATE AN ALIEN LANDSCAPE!

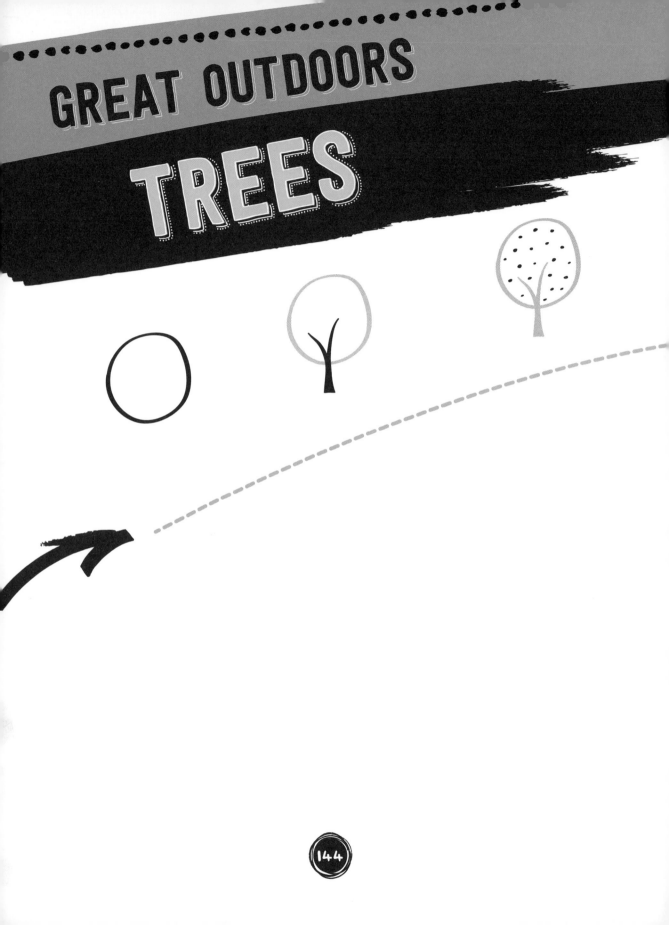

# GREAT OUTDOORS

## TREES

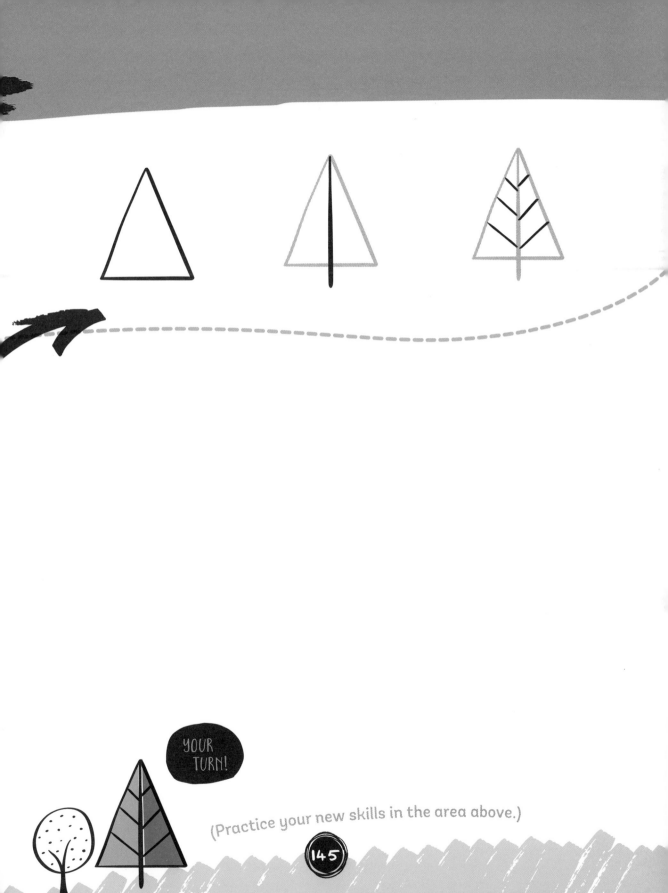

YOUR TURN!

(Practice your new skills in the area above.)

145

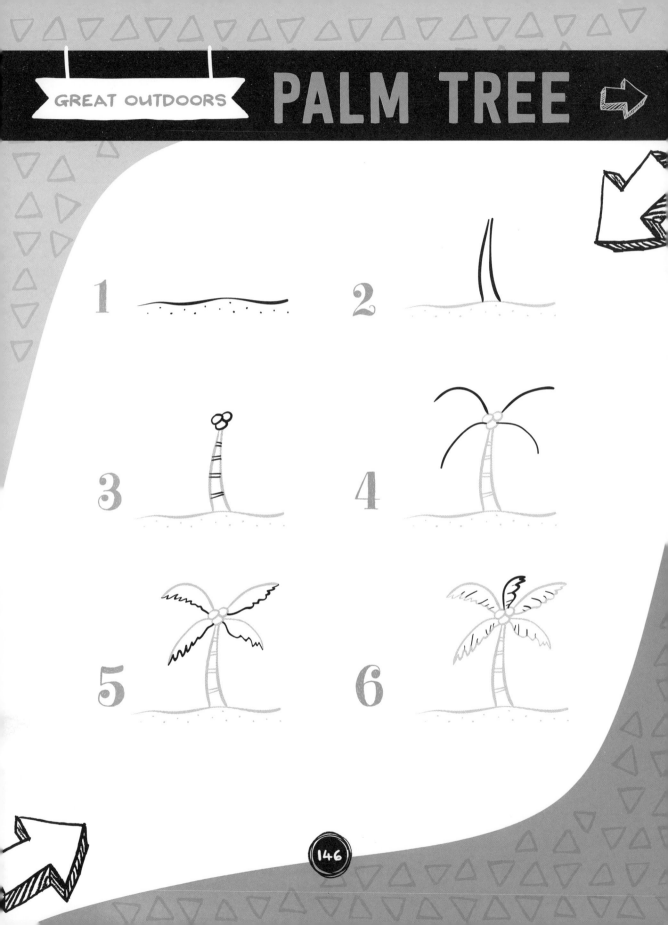

1

2

3

4

5

6

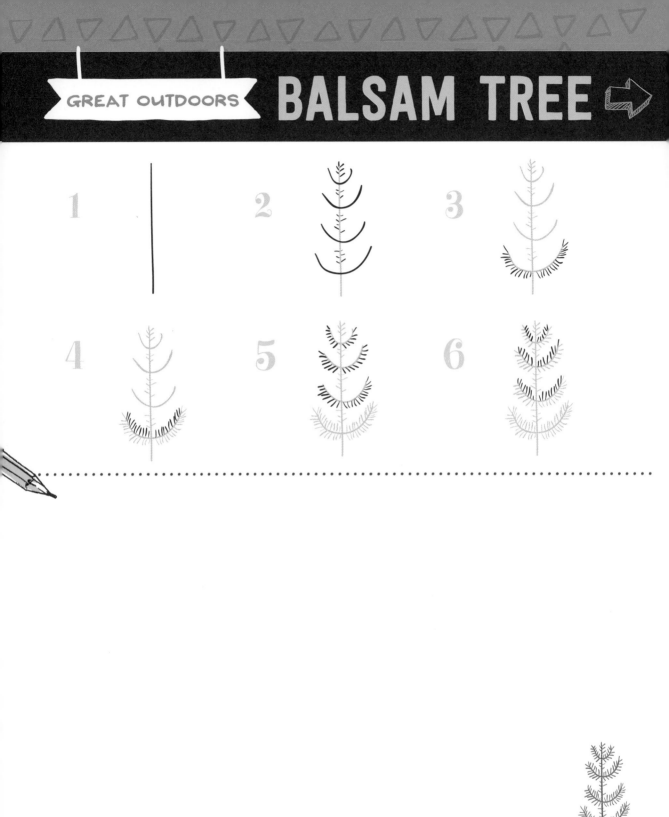

1  2  3

4  5  6

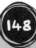

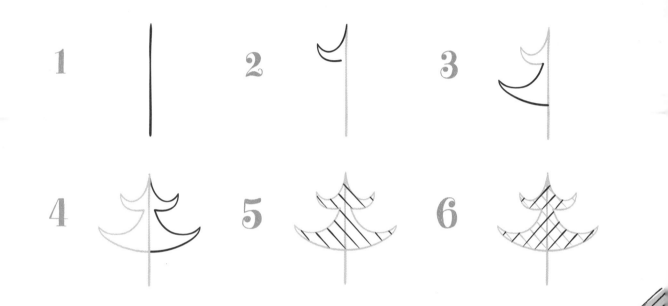

1

2

3

4

5

6

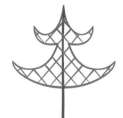

# FOREST

YOUR TURN!

# SMILING SUN

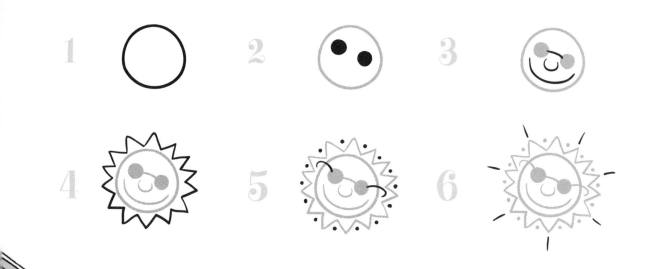

1

2

3

4

5

6

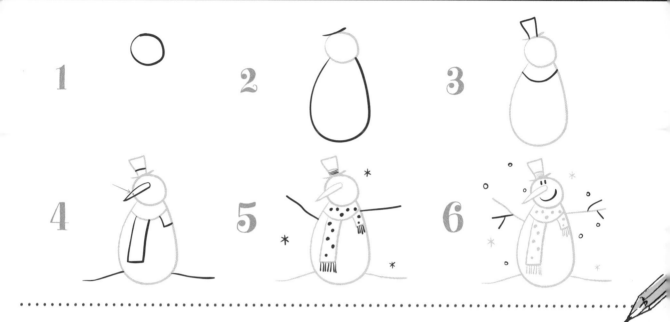

1

2

3

4

5

6

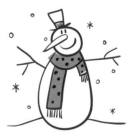

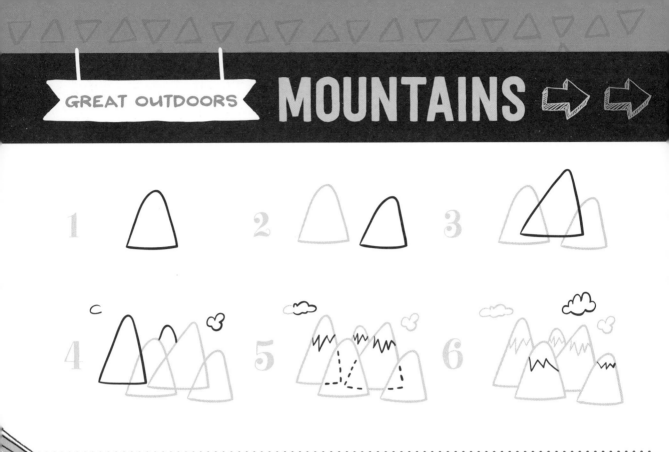

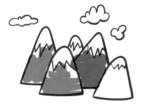

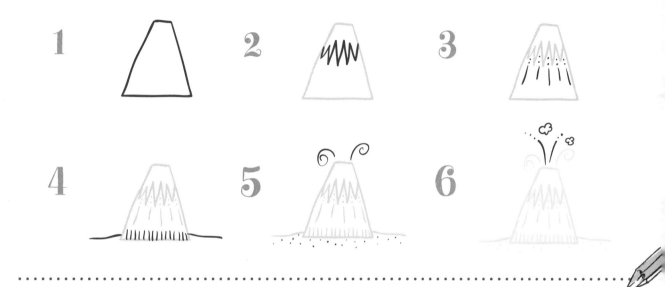

1
2
3
4
5
6

# GREAT OUTDOORS → BAOBAB

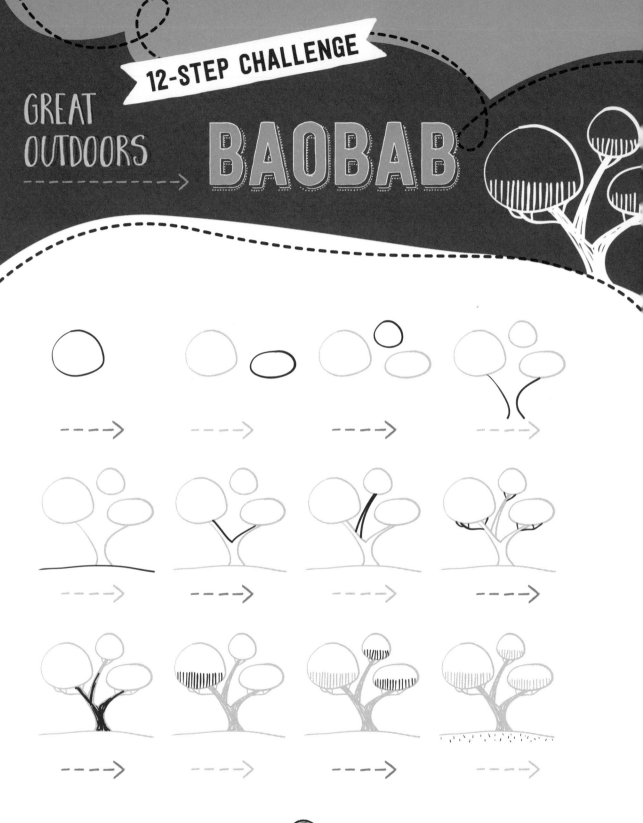

# CHAPTER 10

## PEOPLE

n this chapter you'll learn how to draw people, from their faces to full bodies . . . all in just 6 easy steps! To get even more creative, try some of the suggestions for creating a scene with them on the next page. And don't forget your 12-Step Challenge—see if you can draw the lady with the cake on page 174!

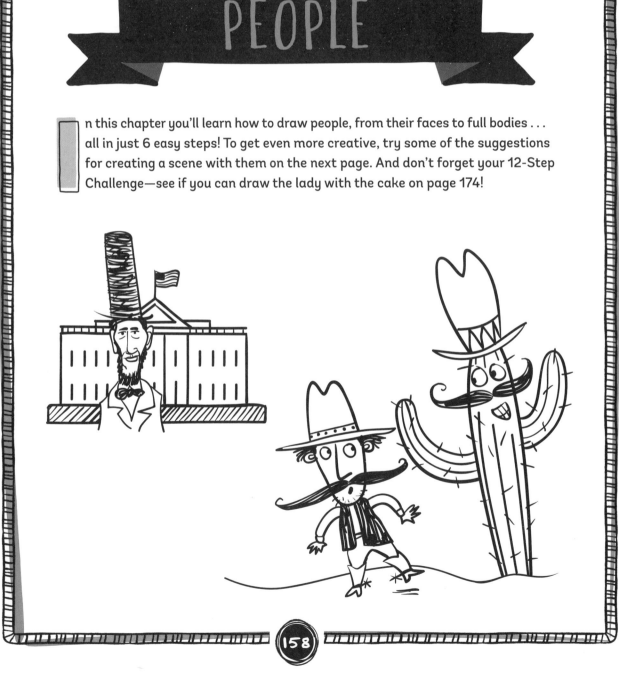

# TRY These TOO!

## People are great for adding some life and action to your scenes.

### HERE'S SOME INSPIRATION

ONCE YOU'VE MASTERED ALL THE PEOPLE IN THIS CHAPTER, TRY MAKING A SCENE WITH THEM! THIS IS THE FUN PART. I PUT SOME SUGGESTIONS BELOW TO JUMP-START YOUR CREATIVITY. AND DON'T HESITATE TO USE YOUR NEW SKETCH SKILLS TO MODIFY ANY OF THE PEOPLE HERE. EXPERIMENT WITH HAIRSTYLES AND ACCESSORIES, OR HAVE THE PEOPLE DO DIFFERENT THINGS. THE SKY IS THE LIMIT!

- TRY DRAWING THE SMILING BOY WITH THE SIGN. WRITE YOUR NAME IN FUN LETTERING ON THE SIGN. DRAW A BIRD STANDING ON ITS HEAD! THEN DRAW THOUGHT BUBBLES FOR THE BOY AND THE BIRD AND WRITE IN WHAT THEY ARE THINKING!

- DRAW THE RUNNING GIRL SOMEPLACE UNEXPECTED . . . LIKE RUNNING DOWN THE SIDE OF THE VOLCANO! WRITE A STORY ABOUT HOW SHE GOT THERE.

- DRAW THE FISHERMAN AT THE EDGE OF A BODY OF WATER. DRAW A COUPLE OF FISH UNDER THE WATER LOOKING AT HIM WITH A FUNNY FACE. DRAW THOUGHT BUBBLES AND WRITE WHAT THEY ARE ALL THINKING!

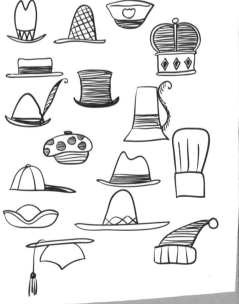

- DRAW THE COWBOY. SEE IF YOU CAN DRAW THE REST OF HIS BODY, WITH COWBOY BOOTS AND A BIG OVAL BELT BUCKLE. DON'T FORGET TO GIVE YOUR CHARACTER A NAME!

- TAKE ONE OF THE FUNNY FACES AND TRY TO DRAW THE REST OF THE BODY. DRAW ONE OF THE HATS ON THE PERSON'S HEAD.

# PEOPLE
## COWBOY

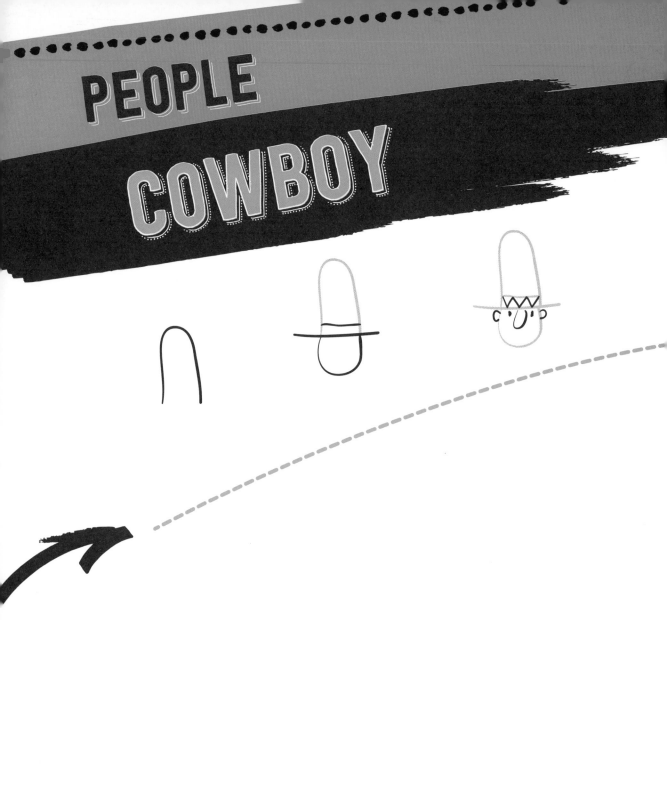

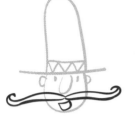

HOWDY!

YOUR TURN!

(Practice your new skills in the area above.)

# ICE SKATER

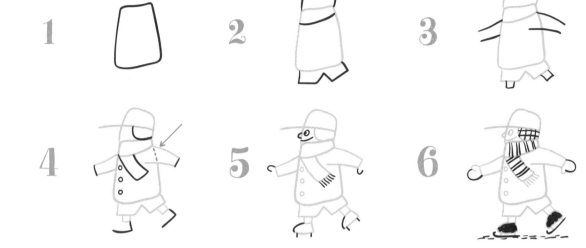

1

2

3

4

5

6

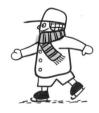

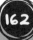

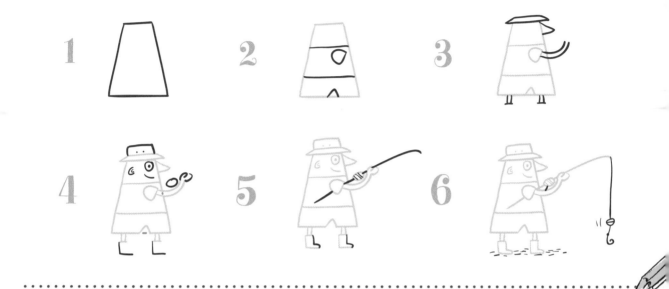

1

2

3

4

5

6

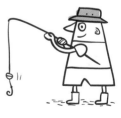

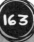

# BOY WITH SIGN

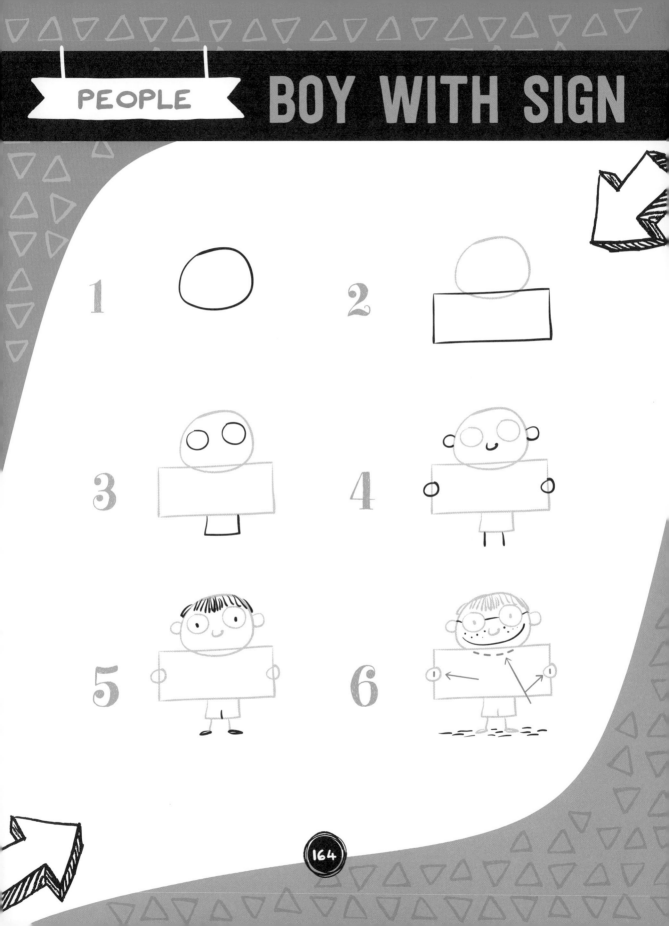

# PEOPLE → KITE FLYER

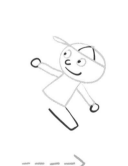

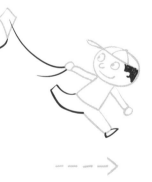

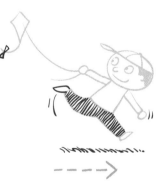

YOUR TURN!

# FREE SPIRIT

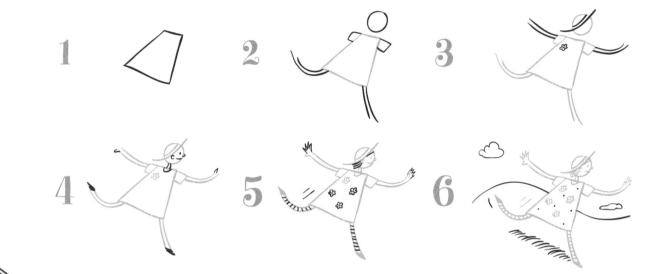

1
2
3
4
5
6

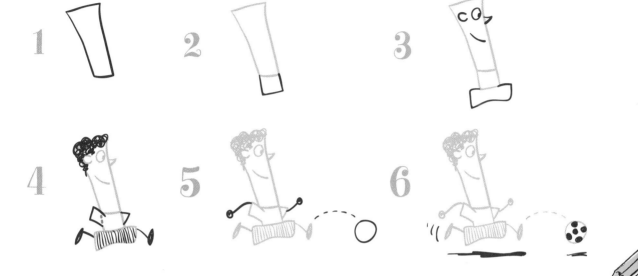

1

2

3

4

5

6

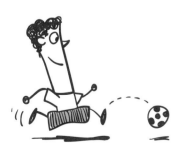

# PEOPLE

## ANGEL

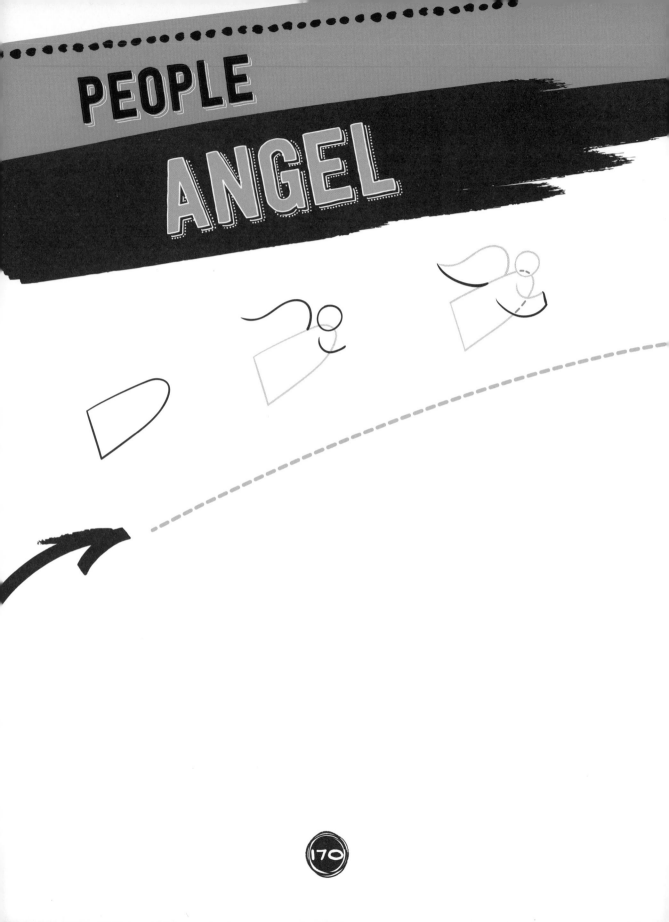

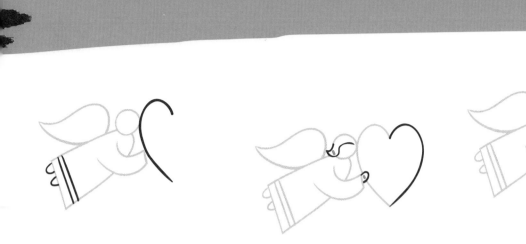

YOUR TURN!

(Practice your new skills in the area above.)

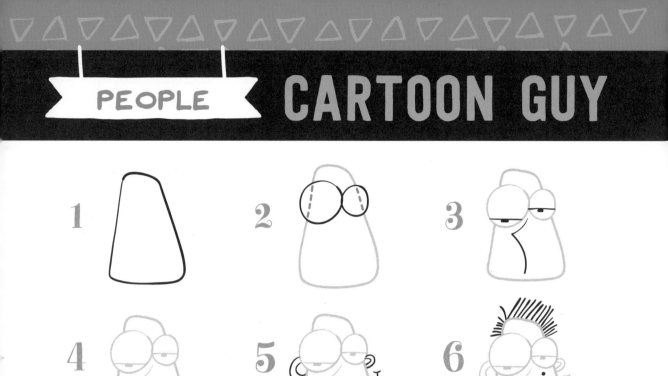

1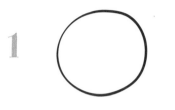

2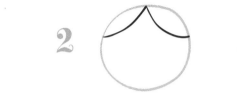

3

4

5

6

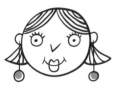

# PEOPLE → CAKE LADY

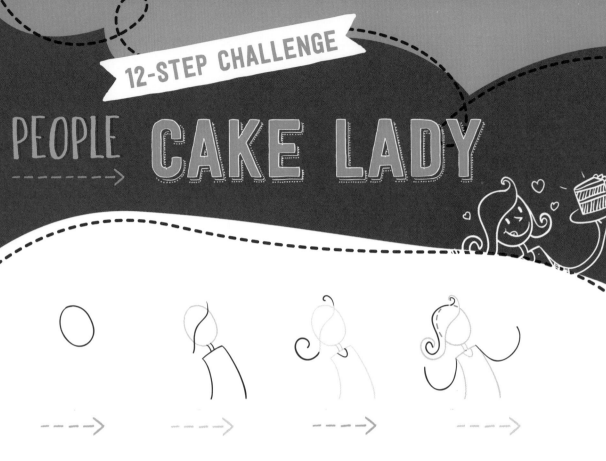

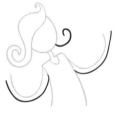

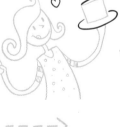

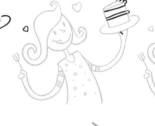

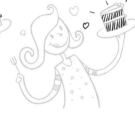

YOUR TURN!

# ACKNOWLEDGMENTS

I want to thank my wife, Angie, who continues to encourage me to pursue my creative ideas and has day by day kept me focused on the path God has laid out for me. I love you, Angie!

# ABOUT THE AUTHOR

Rich Davis is a professional artist, children's book artist, and drawing game inventor. He has published more than 15 books, including the popular *Tiny the Dog* series. Rich teaches drawing instruction at schools and also created *Pick and Draw*, which he developed into both an activity book and game. He lives in Arkansas. On any given day, you might find Rich out on his front porch with his dog, Ringo, drawing with an ink pen in his sketchbook. After 30 years of producing art professionally, drawing simply has become his love.